To Christine and Richard
All the best,

Peter Duggan's

CARTOONS

Peter Duggan's *Artoons* series has been featured on the *Guardian* online since 2011. He spent seven years as a registrar at the Art Gallery of New South Wales in Sydney. In 2005 he moved to London and has worked at prominent London commercial gallery, the Alan Cristea Gallery, and has made the acquaintance of some of the artists he has depicted. Peter has a BA and an MA in Fine Art from the University of New South Wales in Sydney. He has exhibited in group and solo exhibitions, and has painted numerous portrait commissions over the years.

Peter Duggan's

CARTOONS

Virgin BOOKS

For Grace and Zoe

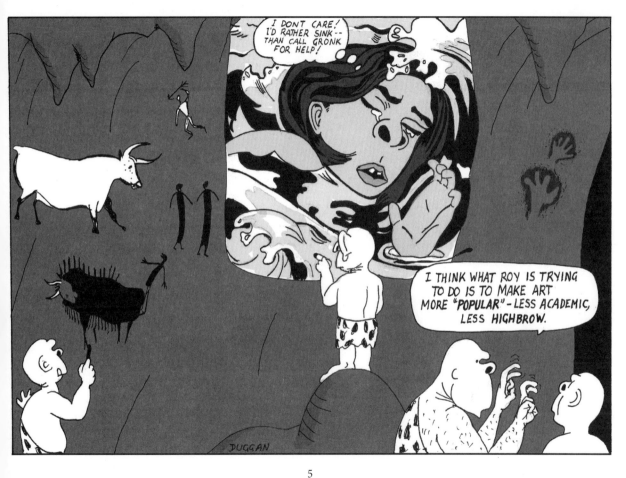

5

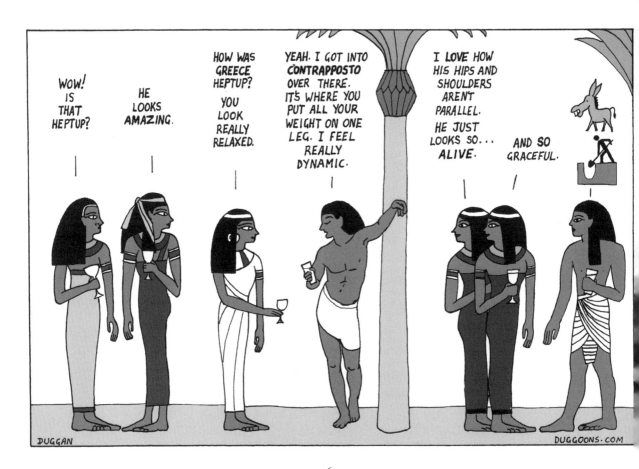

6

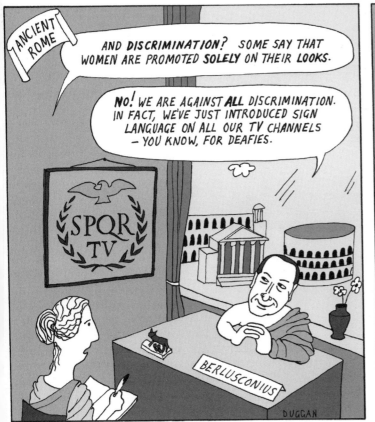

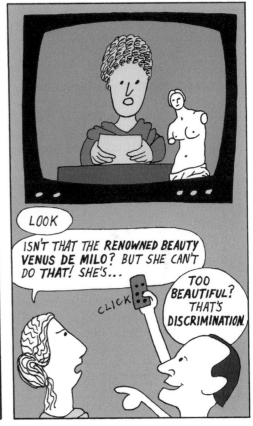

7

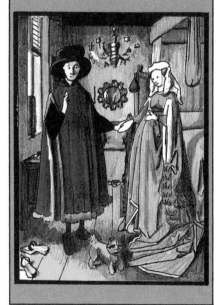

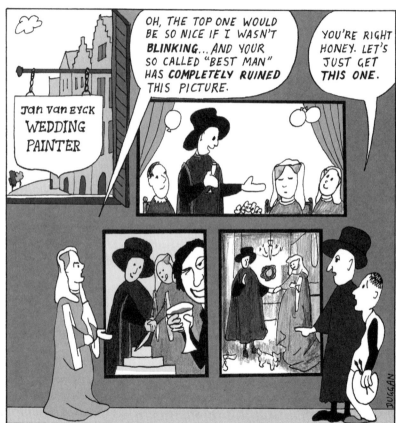

THE HOT GOSS!
ZEUS ABOUT TOWN

"HE WAS SO GRACEFUL" SAYS LEDA.

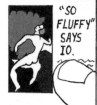

"SO FLUFFY" SAYS IO.

"DAMP SQUIB" SAYS DANAE.

"SUCH A PIG" SAYS EUROPA. "BULL" SAYS ZEUS.

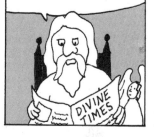

MAN THAT GUY GETS A LOT OF ACTION. BUT IT'S ALL SO **SLEAZY** NOW. NOONE KNOWS HOW TO TREAT A **LADY** ANYMORE.

DIVINE TIMES

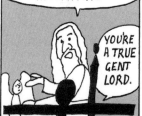

ANGEL OF THE NORTH, I'D LIKE YOU TO GO TO THAT SWEET GIRL **MARY** I KEEP TALKING ABOUT AND **ANNOUNCE** MY INTENTIONS.

YOU'RE A TRUE GENT LORD.

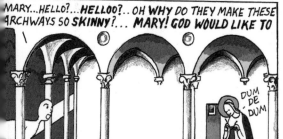

MARY...HELLO?...**HELLOO**?.. OH **WHY DO THEY MAKE THESE** ARCHWAYS SO **SKINNY**?... **MARY! GOD WOULD LIKE TO**

DUM - DE - DUM

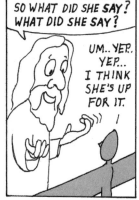

SO WHAT DID SHE **SAY**? WHAT DID SHE SAY?

UM.. YEP. YEP... I THINK SHE'S UP FOR IT.

IT WAS A COMPLETE SCHMOZZLE. THE ANGEL GABRIEL WAS LATER SENT TO CLEAR THINGS UP WITH MARY, WHILE THE ANGEL OF THE NORTH WAS DEMOTED FROM DIVINE MESSENGER TO TOURIST ATTRACTION.

SO...COLD...

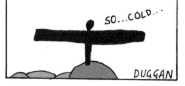

DUGGAN

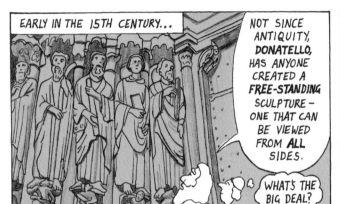

EARLY IN THE 15TH CENTURY...

NOT SINCE ANTIQUITY, **DONATELLO**, HAS ANYONE CREATED A **FREE-STANDING** SCULPTURE — ONE THAT CAN BE VIEWED FROM **ALL** SIDES.

WHAT'S THE BIG DEAL?

FUNNY HOW PEOPLE GET SO MENTALLY **SHACKLED** BY TRADITION.

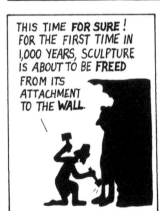

THIS TIME **FOR SURE**! FOR THE FIRST TIME IN 1,000 YEARS, SCULPTURE IS ABOUT TO BE **FREED** FROM ITS ATTACHMENT TO THE **WALL**.

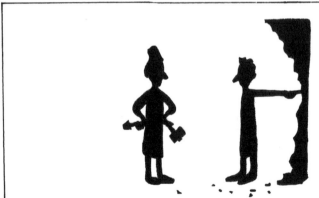

DUGGA

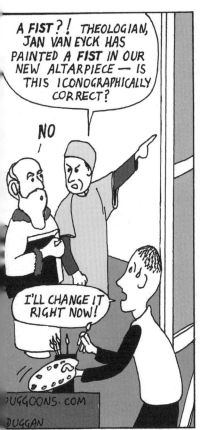

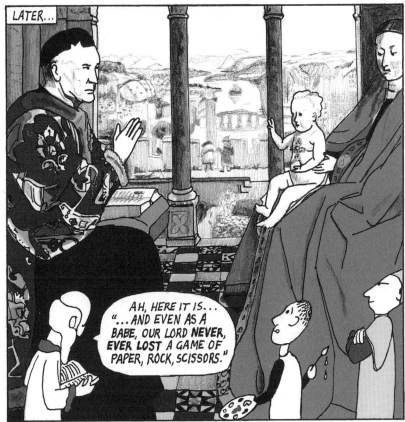

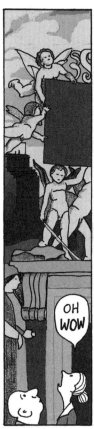

OH WOW

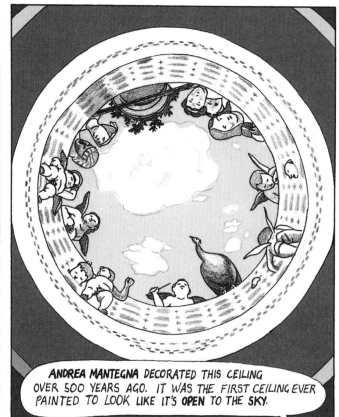

ANDREA MANTEGNA DECORATED THIS CEILING OVER 500 YEARS AGO. IT WAS THE FIRST CEILING EVER PAINTED TO LOOK LIKE IT'S **OPEN** TO THE SKY.

IT'S INCREDIBLY EFFECTIVE.

DUGGAN DUGGOONS.COM

12

I'M SORRY I'M NOT JUMPING FOR **JOY** BUT I JUST HAVE **NO PATERNAL INSTINCTS.**

LOOK, THEY'RE OUR **FRIENDS.** THEY'VE ENDURED **YEARS** OF FERTILITY TESTS, I.V.F. – THE **WORKS** – AND NOW, FINALLY, THEY'VE ADOPTED A 3 MONTH OLD GIRL. IT'S **FANTASTIC!**

CONGRATULATIONS! WE'RE SO HAPPY FOR YOU.

THE BABY'S SLEEPING NOW BUT SHALL WE **SNEAK** A **QUICK PEEK** ?

OOO, YES PLEASE.

GOSH, SHE'S VERY... ADVANCED.

OH THANK YOU. WE THINK SO BUT WE **WOULD** SAY THAT WOULDN'T WE.

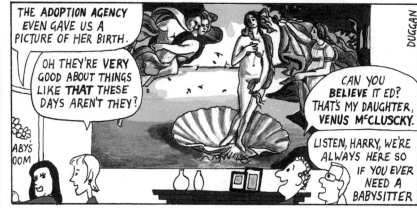

THE ADOPTION AGENCY EVEN GAVE US A PICTURE OF HER BIRTH.

OH THEY'RE **VERY** GOOD ABOUT THINGS LIKE **THAT** THESE DAYS AREN'T THEY?

ABY'S OOM

CAN YOU **BELIEVE** IT ED? THAT'S MY DAUGHTER, **VENUS M°CLUSCKY.**

LISTEN, HARRY, WE'RE ALWAYS HERE SO IF YOU EVER NEED A BABYSITTER

DUGGAN

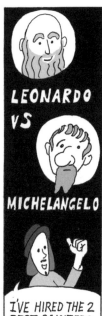

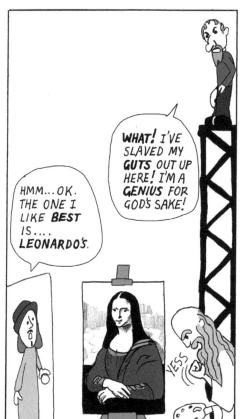

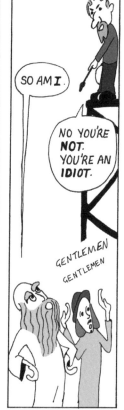

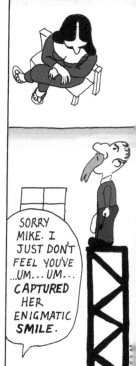

14

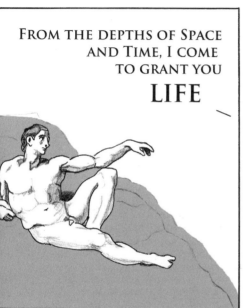

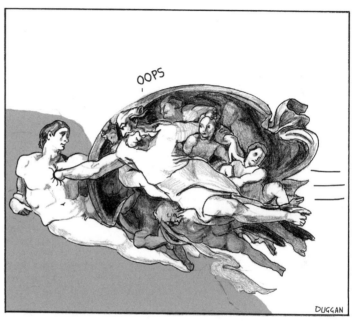

Having lived for eons without matter, without points of reference of any kind, God found it tricky to gauge his speed. (After his subsequent successful attempt with Adam, God forbade any mention of Keith.)

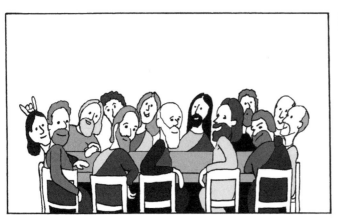
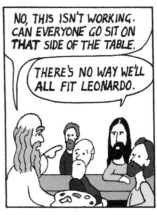

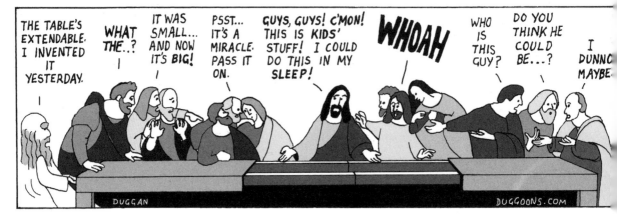

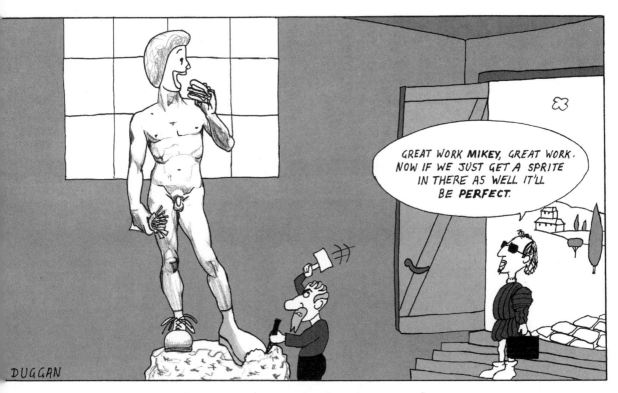

The rise of capitalism marked a change of patronage
for artists.

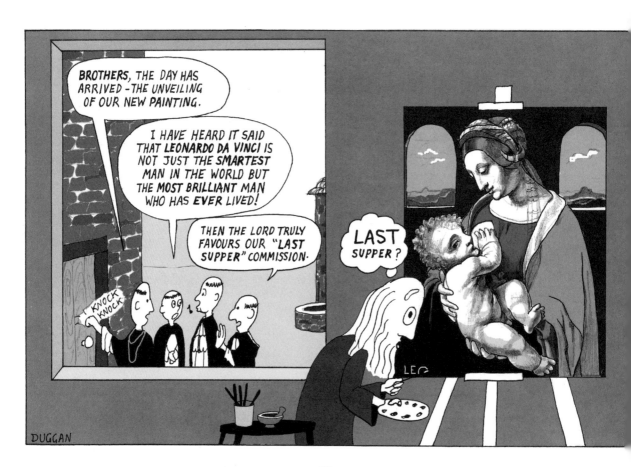

18

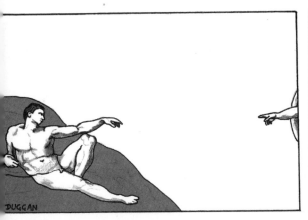

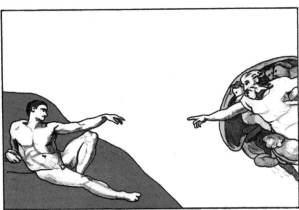

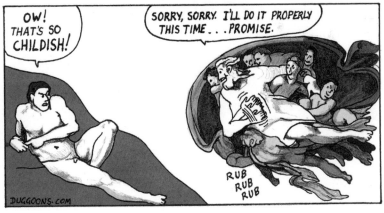

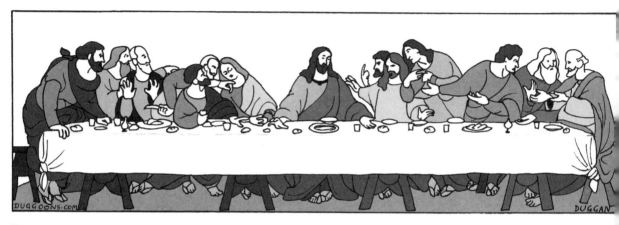

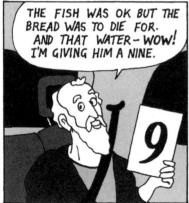

THE FISH WAS OK BUT THE BREAD WAS TO DIE FOR. AND THAT WATER – WOW! I'M GIVING HIM A NINE.

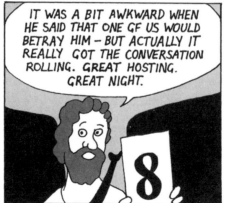

IT WAS A BIT AWKWARD WHEN HE SAID THAT ONE OF US WOULD BETRAY HIM – BUT ACTUALLY IT REALLY GOT THE CONVERSATION ROLLING. GREAT HOSTING. GREAT NIGHT.

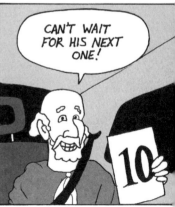

CAN'T WAIT FOR HIS NEXT ONE!

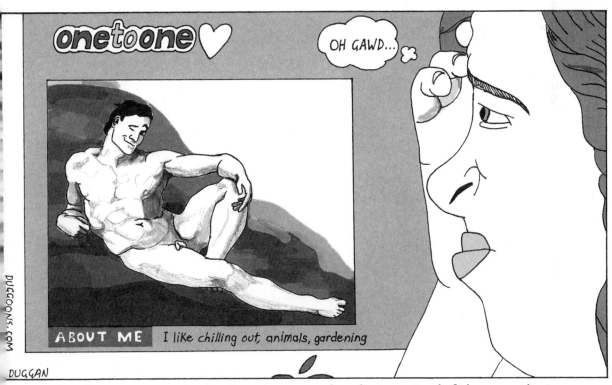

The discouraging lack of options on the dating site left her no choice;
Eve clicked 'like'.

Masterpiece by Arcimboldo ruined in restoration attempt by amateur art restorer

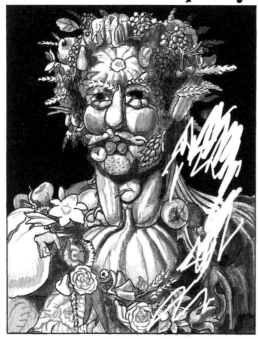

BEFORE

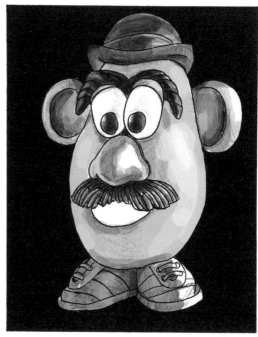

AFTER

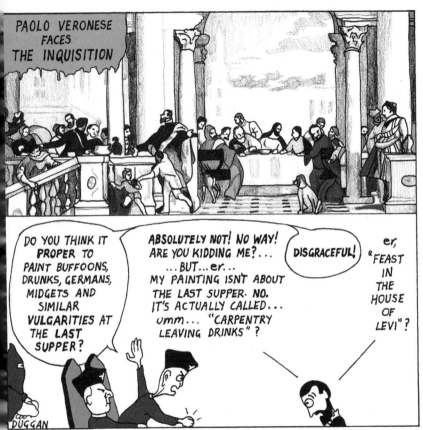

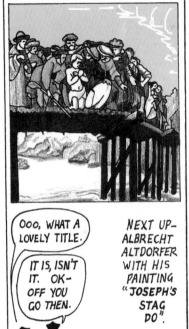

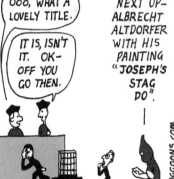

23

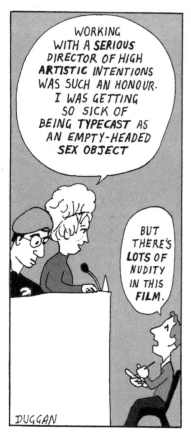

WORKING WITH A **SERIOUS** DIRECTOR OF HIGH **ARTISTIC** INTENTIONS WAS SUCH AN HONOUR. I WAS GETTING SO SICK OF BEING **TYPECAST** AS AN EMPTY-HEADED **SEX OBJECT**

BUT THERE'S **LOTS OF** NUDITY IN THIS **FILM**.

DUGGAN

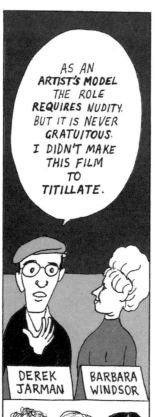

AS AN **ARTIST'S MODEL** THE ROLE **REQUIRES** NUDITY. BUT IT IS NEVER **GRATUITOUS**. I DIDN'T MAKE THIS FILM TO **TITILLATE**.

DEREK JARMAN

BARBARA WINDSOR

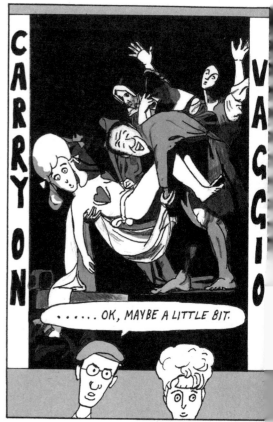

CARRY ON VAGGIO

...... OK, MAYBE A LITTLE BIT.

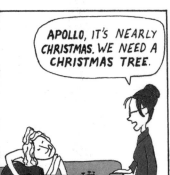
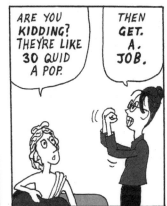
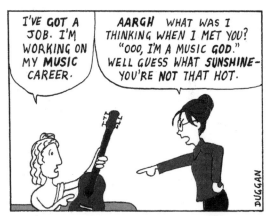
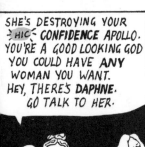
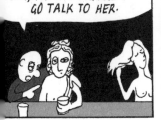
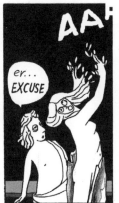
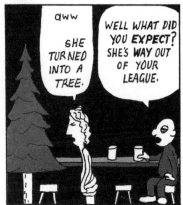
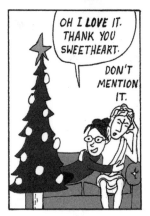

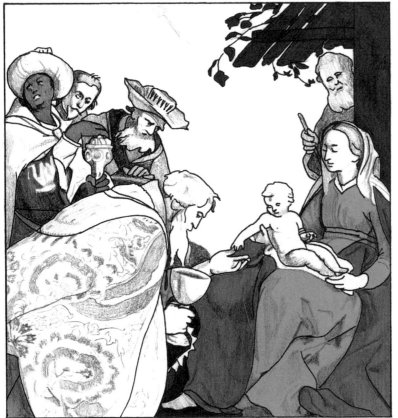

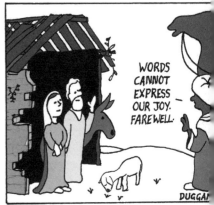

WORDS CANNOT EXPRESS OUR JOY. FAREWELL.

DUGGAN

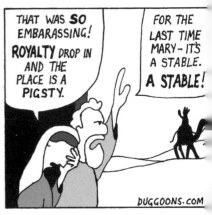

THAT WAS **SO** EMBARASSING! **ROYALTY** DROP IN AND THE PLACE IS A PIGSTY.

FOR THE LAST TIME MARY – IT'S A STABLE. **A STABLE!**

DUGGOONS.COM

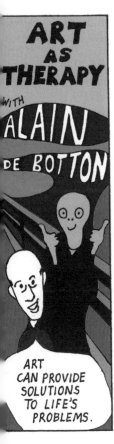

ART
AS
THERAPY

WITH

ALAIN

DE BOTTON

ART CAN PROVIDE SOLUTIONS TO LIFE'S PROBLEMS.

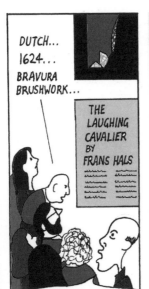

DUTCH... 1624... BRAVURA BRUSHWORK...

THE LAUGHING CAVALIER BY FRANS HALS

IGNORE LABELS. THEY NEVER TELL US ANYTHING TRULY MEANINGFUL. HOWEVER, IF WE ARE OPEN AND SENSITIVE, THE PAINTING CONTAINS A MESSAGE WE CAN ACTUALLY USE.

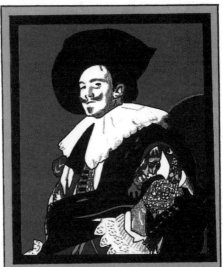

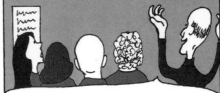

WHICH IS... TO LAUGH UPROARIOUSLY IN THE FACE OF LIFE'S TRAVAILS — TO HAVE A CAVALIER ATTITUDE TOWARDS THEM.

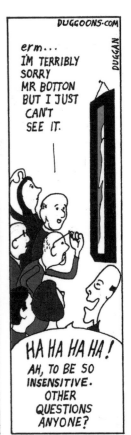

DUGGAN

erm... I'M TERRIBLY SORRY MR BOTTON BUT I JUST CAN'T SEE IT.

HA HA HA HA! AH, TO BE SO INSENSITIVE. OTHER QUESTIONS ANYONE?

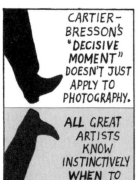

CARTIER-BRESSON'S *"DECISIVE MOMENT"* DOESN'T JUST APPLY TO PHOTOGRAPHY.

ALL GREAT ARTISTS KNOW INSTINCTIVELY **WHEN** TO STRIKE.

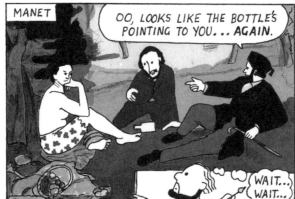

MANET

OO, LOOKS LIKE THE BOTTLE'S POINTING TO YOU... **AGAIN.**

WAIT... WAIT...

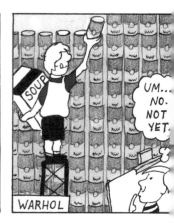

SOUP

UM... NO. NOT YET.

WARHOL

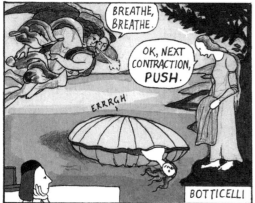

BREATHE, BREATHE.

OK, NEXT CONTRACTION, **PUSH.**

ERRRGH

BOTTICELLI

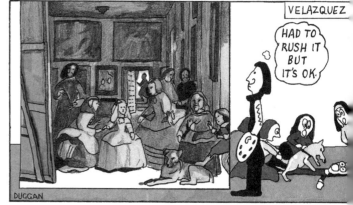

VELAZQUEZ

HAD TO RUSH IT BUT IT'S OK.

DUGGAN

28

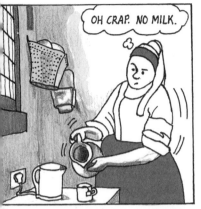

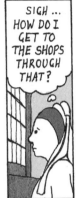

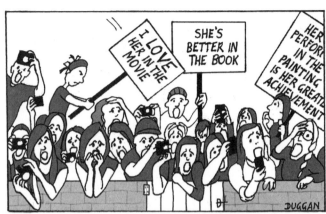

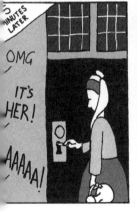

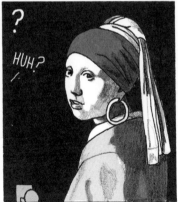

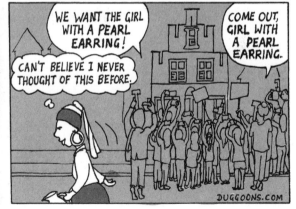

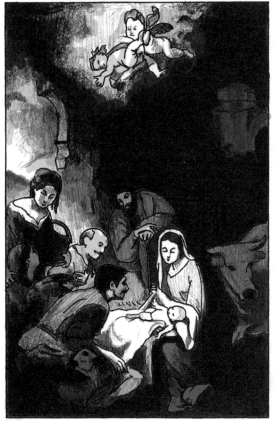

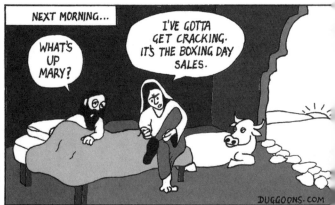

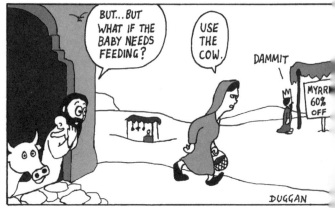

30

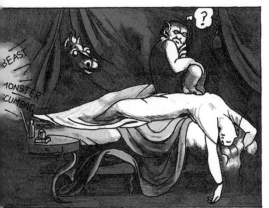

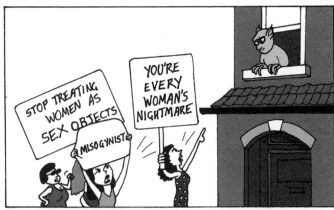

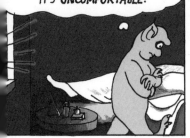

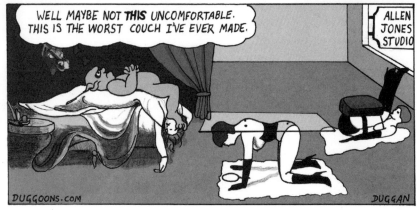

Publius Horatius
5 seconds ago

Me and my bros about to fight some other dudes to the death to save our city... **OMFG!**

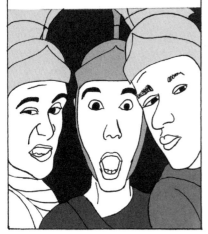

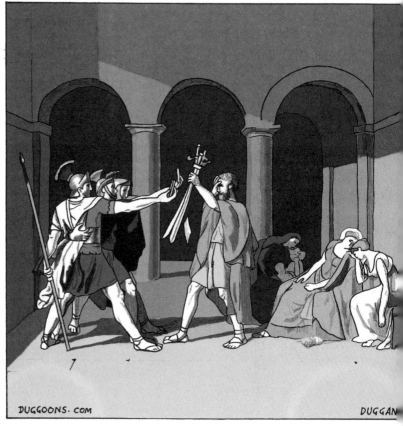

DUGGOONS. COM

DUGGAN

32

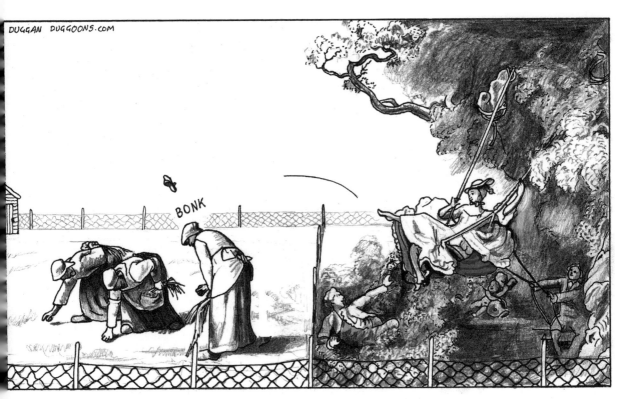

Historians have long suspected a correlation between the French Revolution and allotment gardening.

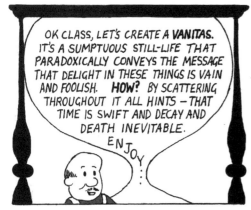

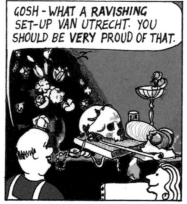

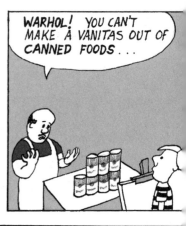

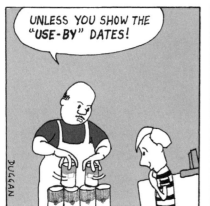

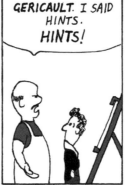

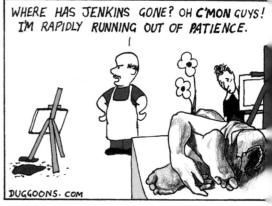

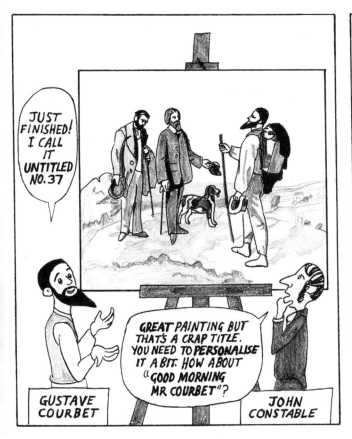

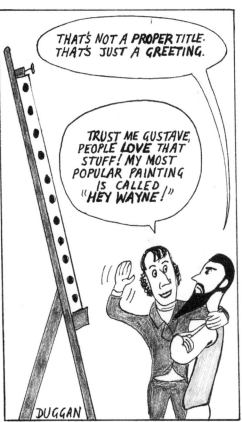

35

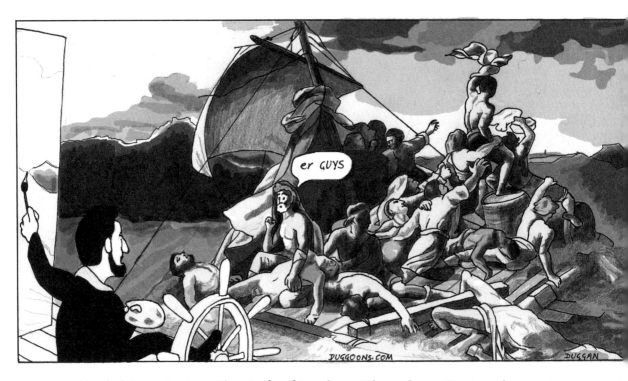

With his painting *The Raft of Medusa*, Theodore Gericault went to extraordinary lengths to capture that desperate moment of hope when the survivors spotted a ship in the distance.

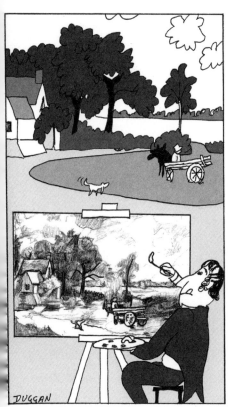
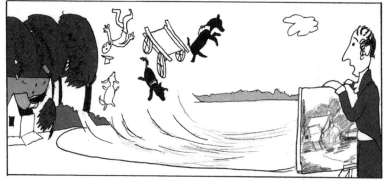
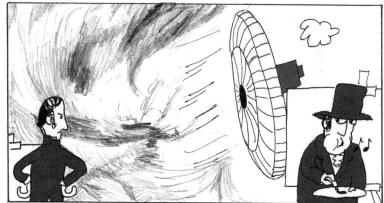

Constable and Turner's relationship was best described as passive aggressive.

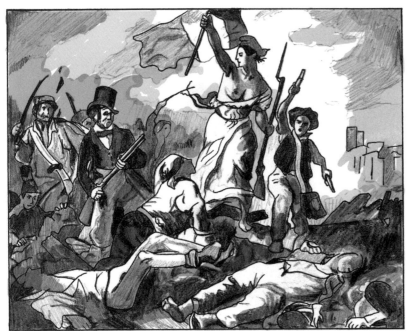 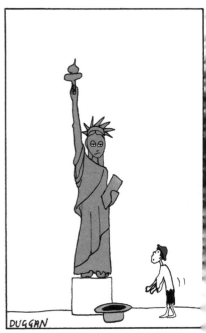

DUGGAN

People remember Liberty Leading the People mainly for the "incident". Liberty herself always insisted it wasn't a publicity stunt but a wardrobe malfunction. However, her career was ruined and eventually she became a buske

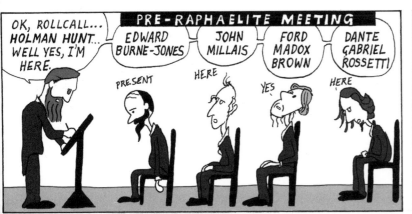

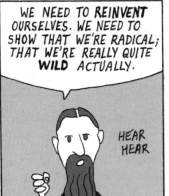

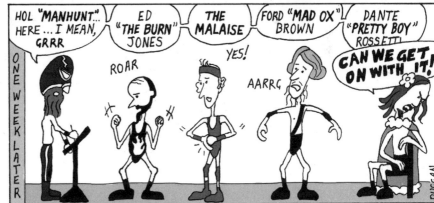

39

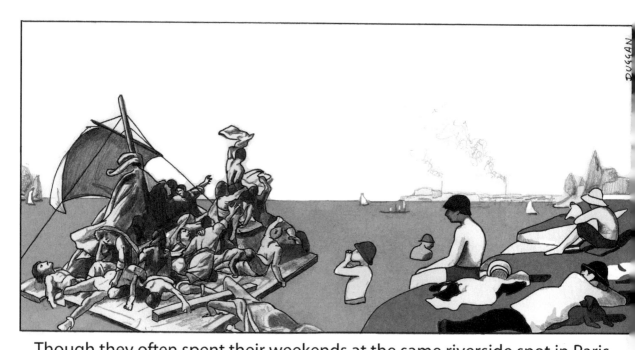

Though they often spent their weekends at the same riverside spot in Paris,
the Pointillists and the Romantics rarely socialised.
The Romantics found the Pointillists to be quite unhelpful, while the Pointillists
thought the Romantics were a bunch of attention-seeking drama queens.

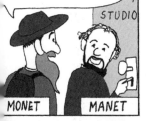

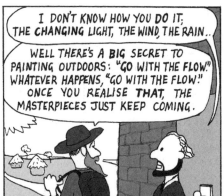

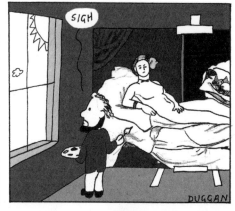

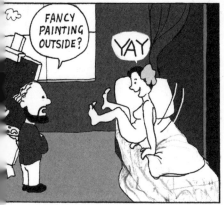

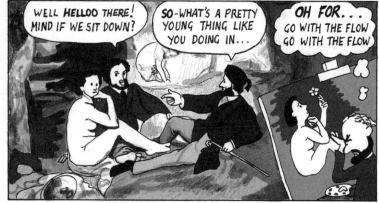

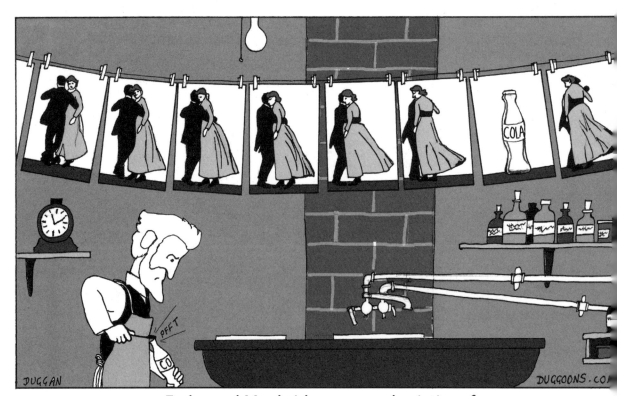

Eadweard Muybridge – an early victim of
subliminal advertising.

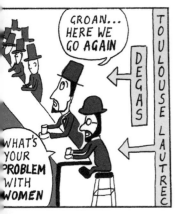

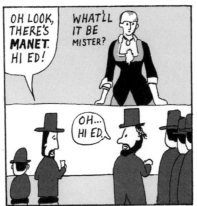

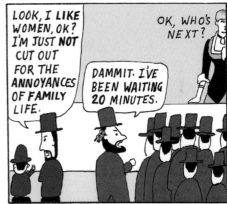

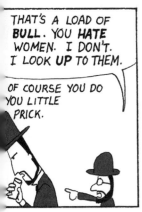

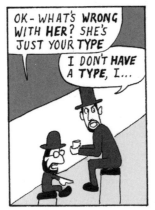

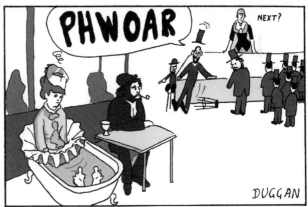

43

REVEALED!

CRIMINAL RECORDS OF ART WORLD STARS

VENUS DE MILO
ATTEMPTED ARMED ROBBERY

JUDITH
OBTAINING PROPERTY BY DECEPTION

LEDA
UNLAWFUL ACT ON AN AIRCRAFT

PABLO PICASSO
DISORDERLY CONSTRUCT

JANE DOE
SERVING ALCOHOL TO A MINOR

TOULOUSE-LAUTREC
FAILURE TO PRODUCE PROOF OF AGE ON A
LICENSED PREMISES, UNDERAGE DRINKING,
SWEARING AT A POLICE OFFICER,
RESISTING ARREST

DUGGAN DUGGOONS.COM

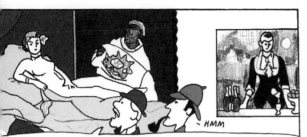

THIS **MANET** FELLOW OFTEN HAS HIS MODELS STARING STRAIGHT AT THE VIEWER. I WONDER WHY SHERLOCK? ANYWAY, TIME FOR A DRINK.

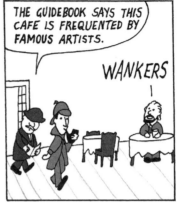

THE GUIDEBOOK SAYS THIS CAFE IS FREQUENTED BY FAMOUS ARTISTS.

WANKERS

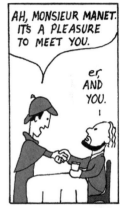

AH, MONSIEUR **MANET**. IT'S A PLEASURE TO MEET YOU.

er, AND YOU.

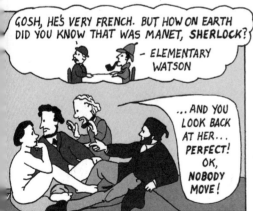

GOSH, HE'S VERY FRENCH. BUT HOW ON EARTH DID YOU KNOW THAT WAS MANET, SHERLOCK?

– ELEMENTARY WATSON

...AND YOU LOOK BACK AT HER... PERFECT! OK, NOBODY MOVE!

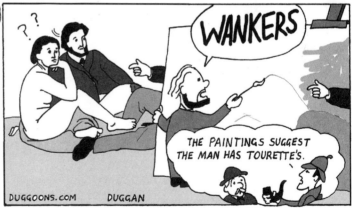

WANKERS

THE PAINTINGS SUGGEST THE MAN HAS TOURETTE'S.

DUGGOONS.COM DUGGAN

45

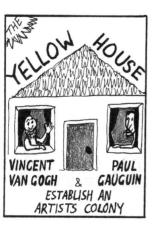

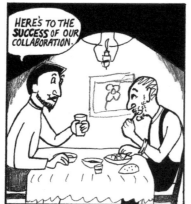

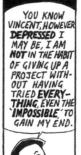

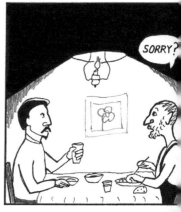

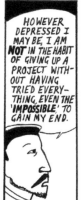

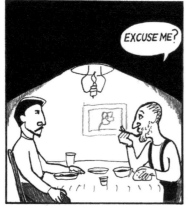

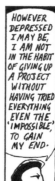

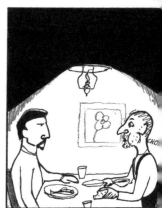

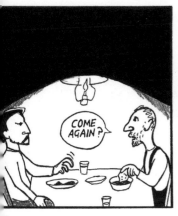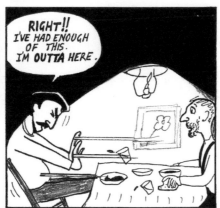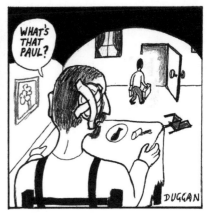

47

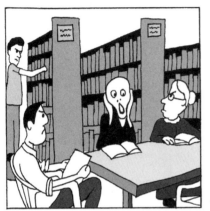
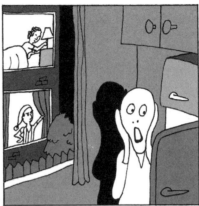
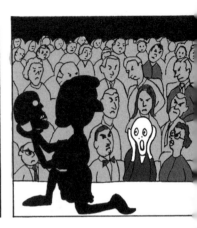
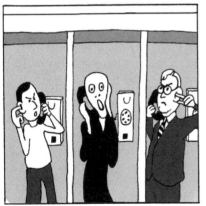
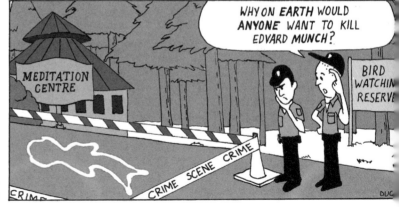

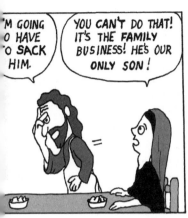
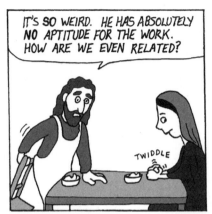
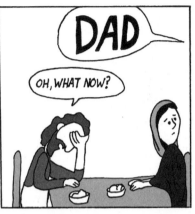
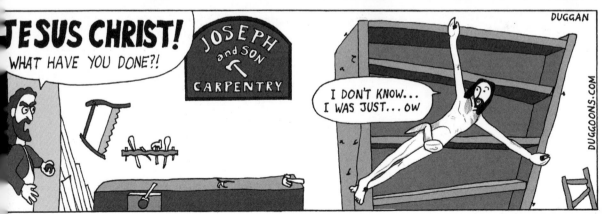

49

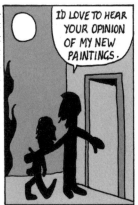

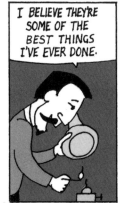

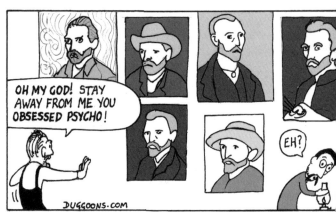

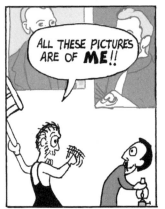

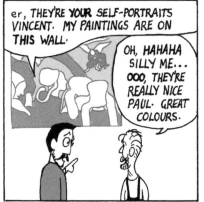

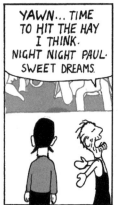

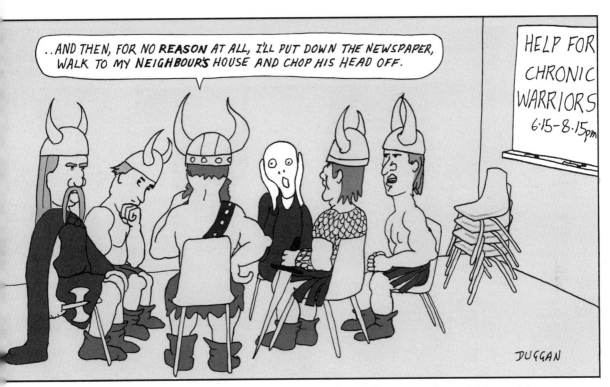

Joining a support group didn't help. If anything, Edvard Munch's chronic worrying just got worse.

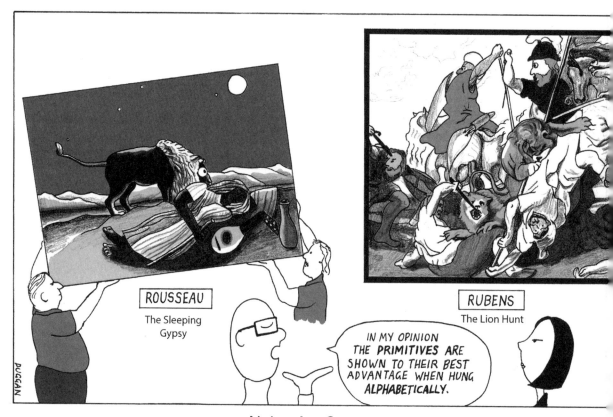

Naive Art Curator

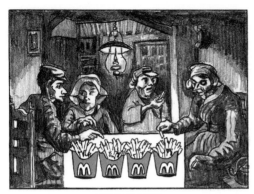

ANDY WARHOL

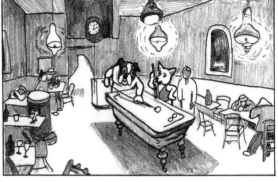

ARTHUR SARNOFF

DUGGAN

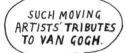

JASPER JOHNS

ROBERT INDIANA

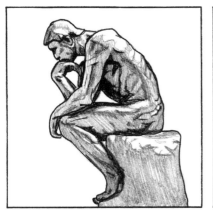
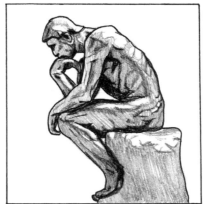
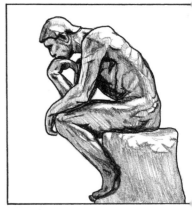
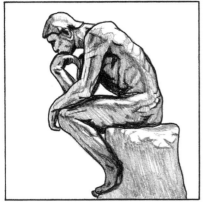
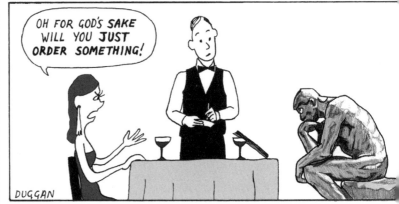

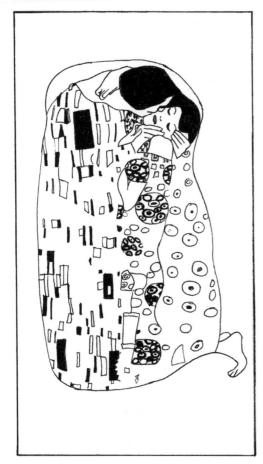

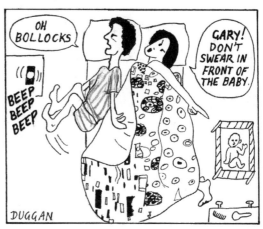

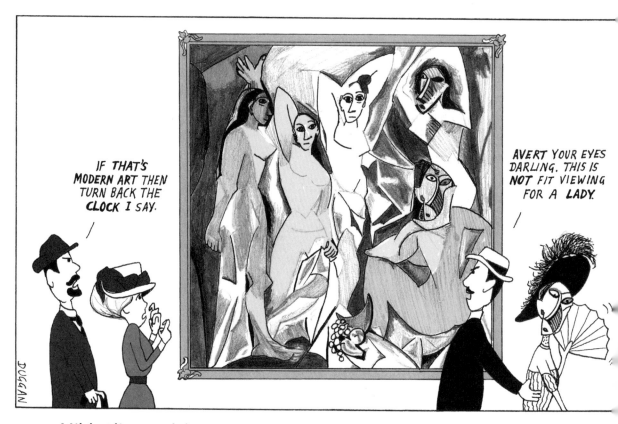

Mildred's scandalous past as an artist's model was never discovered.

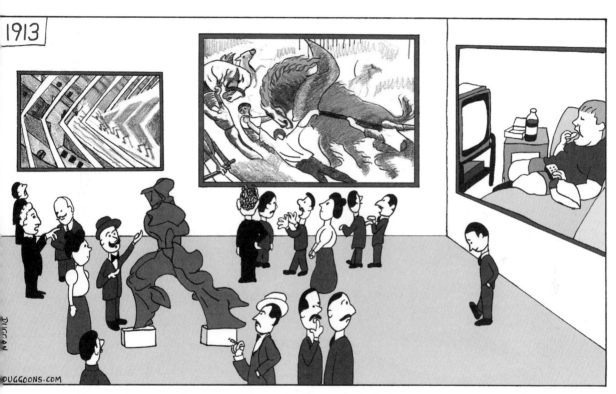

Misunderstood, ignored and ultimately forgotten. The sad fate
of Futurism's most visionary artist.

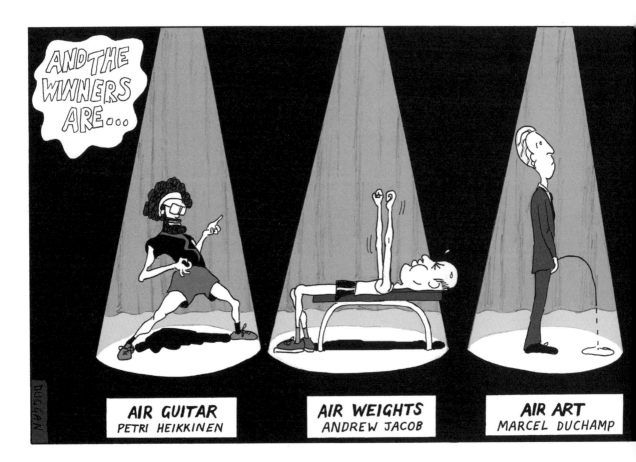

Nude Descending a Staircase

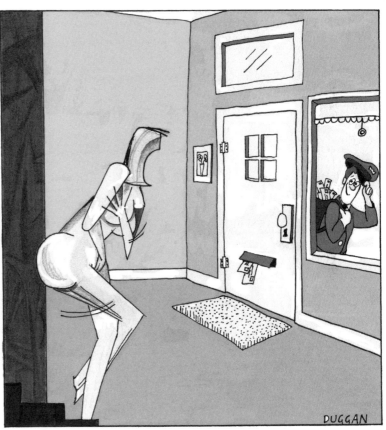

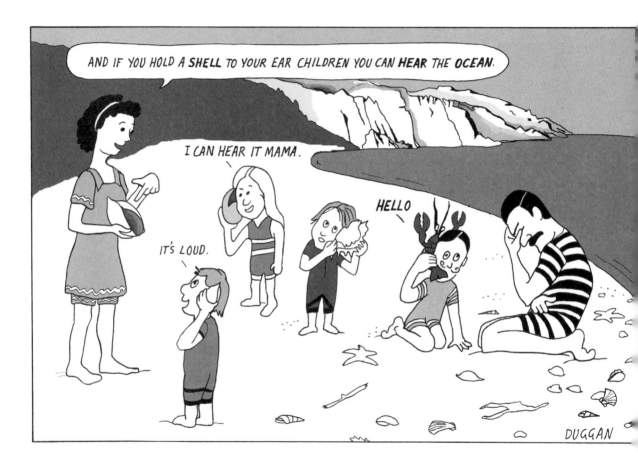

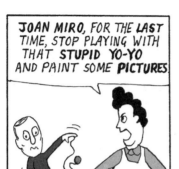
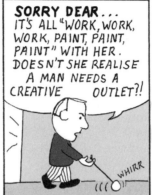
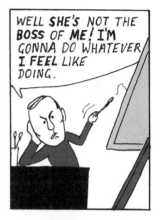
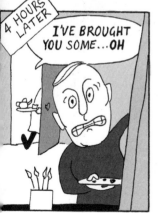
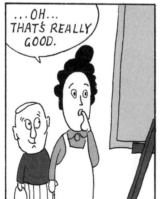
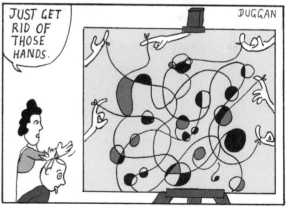

61

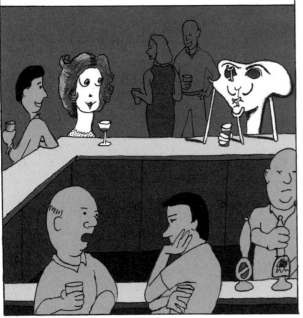

THEIR EYES MET. INSTANTLY THEY WERE BOTH OVERWHELMED BY A FEELING OF PROFOUND **CONNECTION.** HERE WAS SOMEONE WHO **KNEW** WHAT IT FELT LIKE TO BE DIFFERENT. WITH A TREMBLING THRILL, THESE TWO **LONELY SURREALISTS** SUDDENLY UNDERSTOOD THAT THEIR DAYS OF LONELINESS WERE OVER.

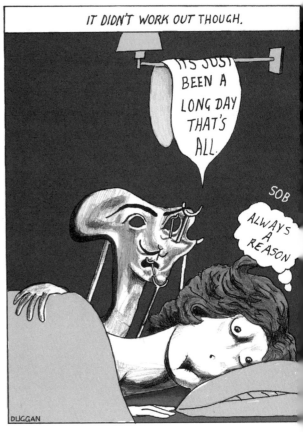

IT DIDN'T WORK OUT THOUGH.

IT'S JUST BEEN A LONG DAY THAT'S ALL.

SOB

ALWAYS A REASON

DUGGAN

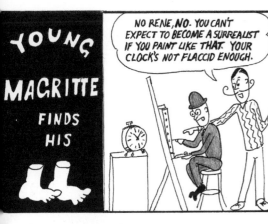
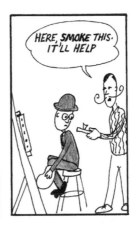
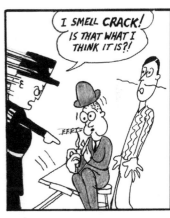
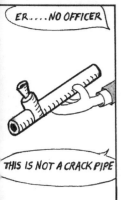
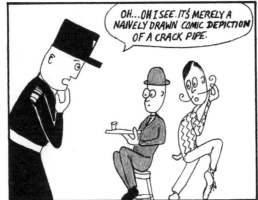
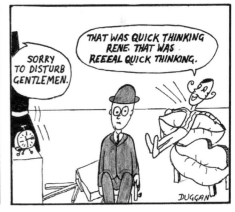

63

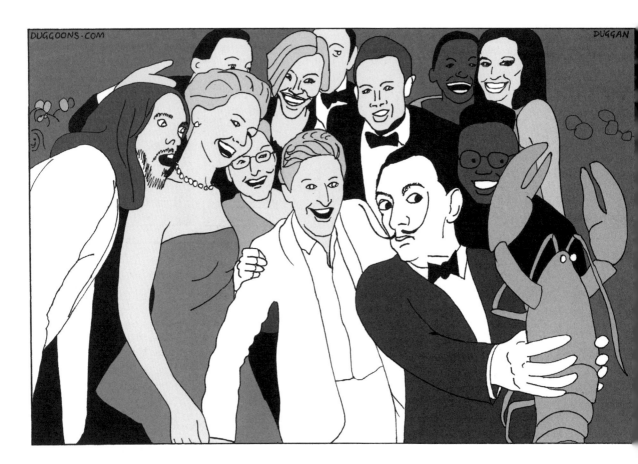

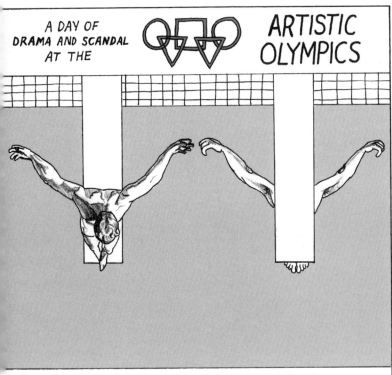

A DAY OF DRAMA AND SCANDAL AT THE **ARTISTIC OLYMPICS**

AFTER A SERIES OF ABYSMAL RESULTS IN THE SYNCHRONISED DIVING, **SALVADOR DALI** RELEASES A STATEMENT: "MY DIVING PARTNER *M.C.ESCHER* IS A JERK."

ITALIAN WRESTLER STRIPPED OF GOLD MEDAL AFTER TESTING POSITIVE FOR HUMAN GROWTH HORMONE.

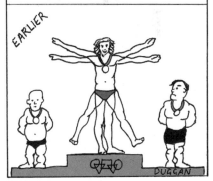

EARLIER

DUGGAN

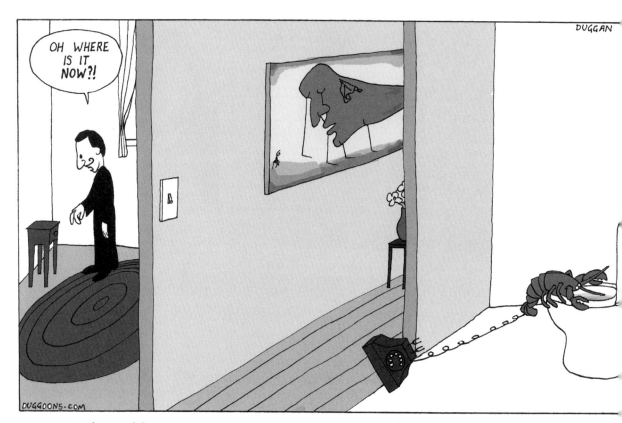

Dali couldn't comprehend why anyone would want a mobile phone.

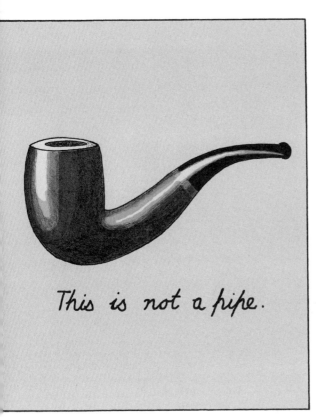

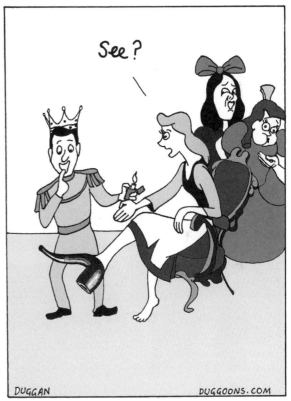

Cinderella nabs a prince.

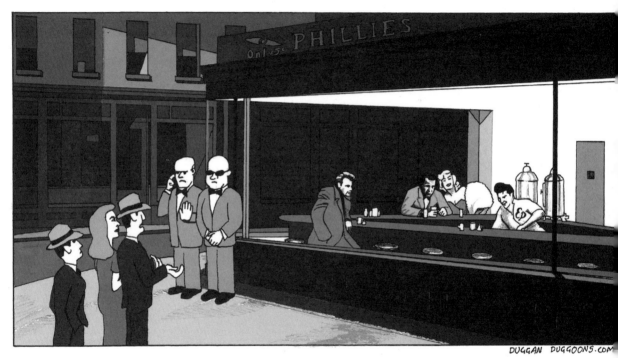

Edward Hopper's paintings are renowned for their powerful sense of alienation.

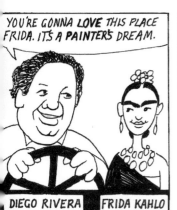

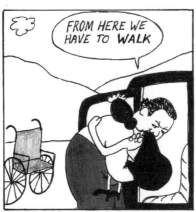

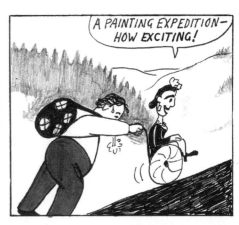

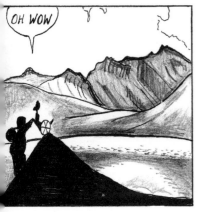

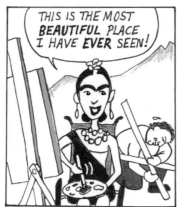

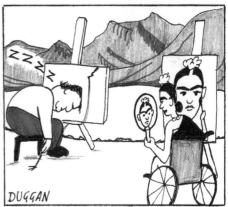

69

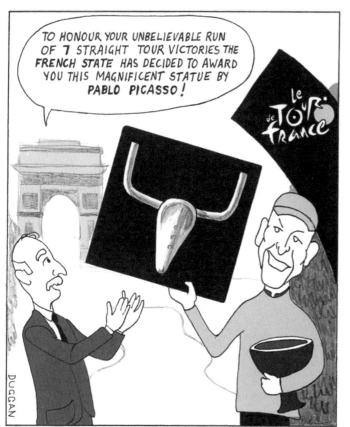

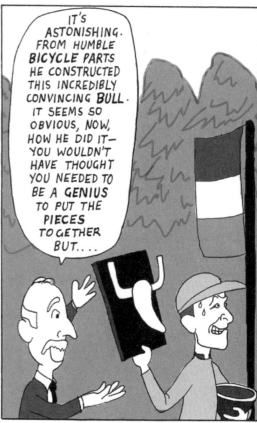

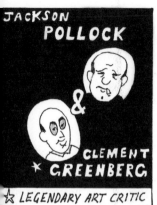
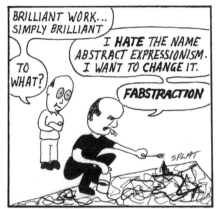
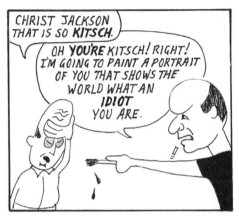
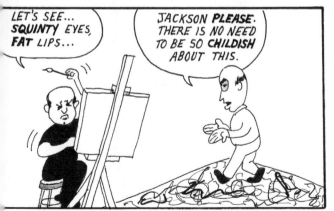
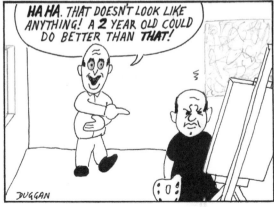

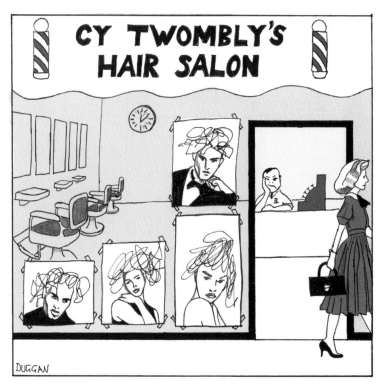

Long before he was acclaimed as one of the world's greatest painters, Cy Twombly was known to many as the world's worst hairdresser.

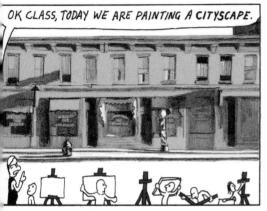

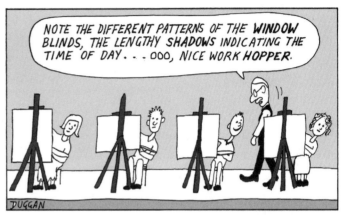

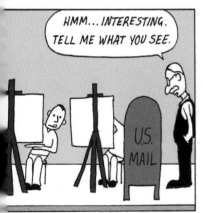

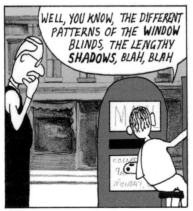

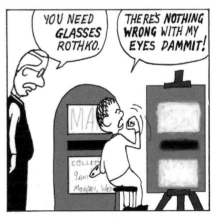

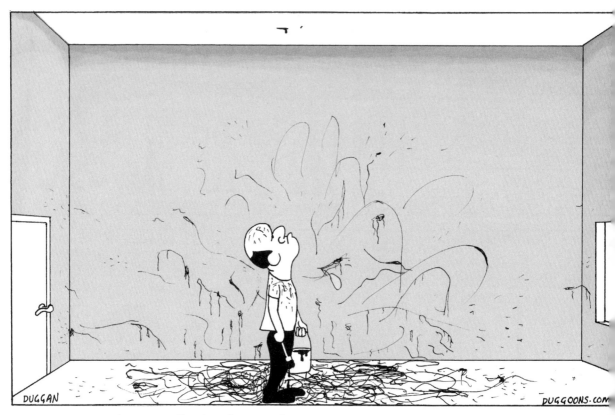

Jackson Pollock's first ceiling commission was also his last.

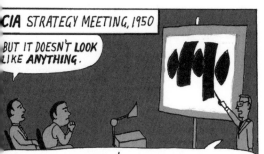

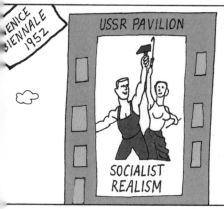

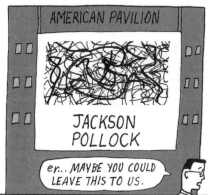

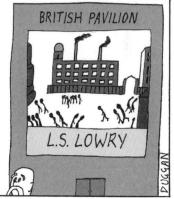

ANDREW **WARHOLA** CHANGED HIS NAME TO **ANDY WARHOL** WHEN HE EMIGRATED TO **AMERICA** FROM THE **PLANET VULCAN**

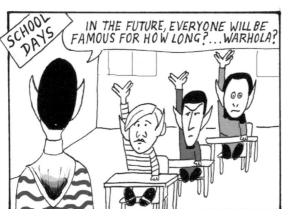

SCHOOL DAYS

IN THE FUTURE, EVERYONE WILL BE FAMOUS FOR HOW LONG?...WARHOLA?

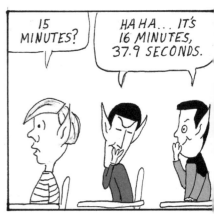

15 MINUTES?

HA HA... IT'S 16 MINUTES, 37.9 SECONDS.

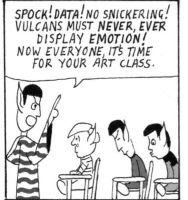

SPOCK! DATA! NO SNICKERING! VULCANS MUST NEVER, EVER DISPLAY EMOTION! NOW EVERYONE, IT'S TIME FOR YOUR ART CLASS.

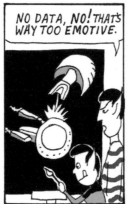

NO DATA, NO! THAT'S WAY TOO EMOTIVE.

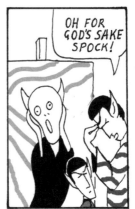

OH FOR GOD'S SAKE SPOCK!

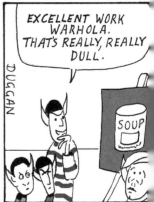

EXCELLENT WORK WARHOLA. THAT'S REALLY, REALLY DULL.

SOUP

DUGGAN

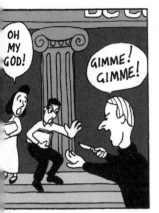

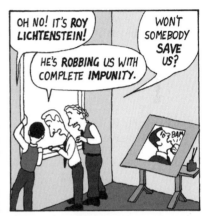

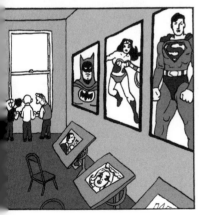

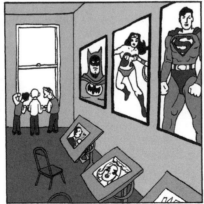

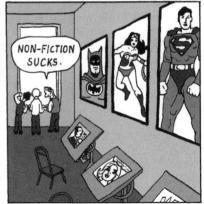

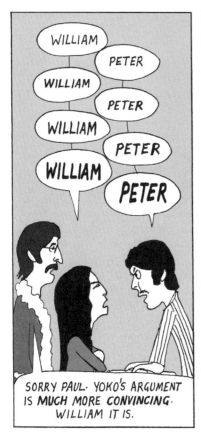

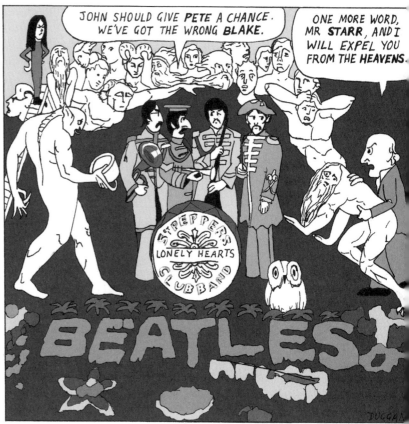

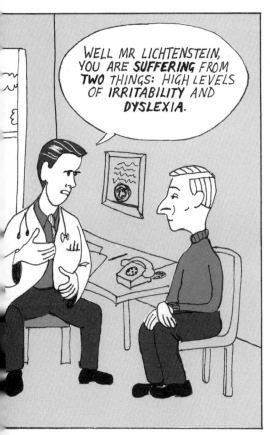

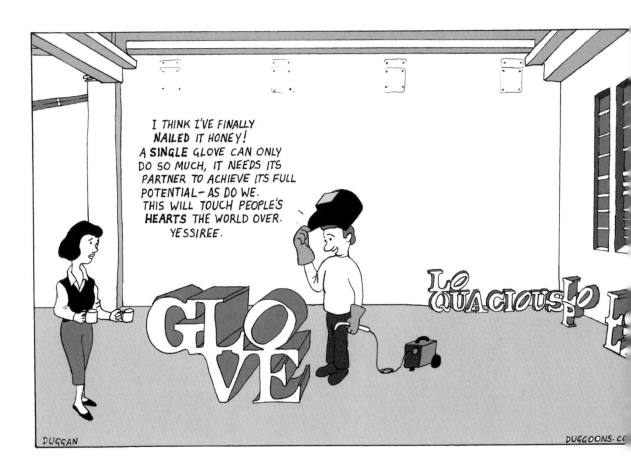

Alain de Botton

PRESENTS

ART AS THERAPY

ART PROVIDES POWERFUL SOLUTIONS TO OUR PROBLEMS.

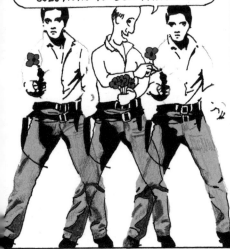

SOME PEOPLE VIEW **POP ART** AS JUST **CRASS** POPULAR CULTURE PARADING AS HIGH ART. IN FACT, IT IS FULL OF PENETRATING INSIGHTS INTO EVERY ASPECT OF OUR LIVES.

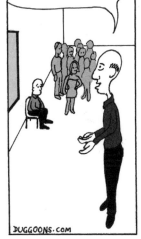

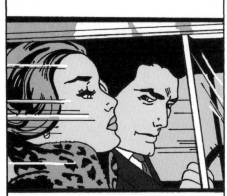

ROY LICHTENSTEIN IS PARTICULARLY **ASTUTE** ON MATTERS OF THE **HEART**. HERE HE TELLS US: "IF YOU WANT A RELATIONSHIP TO WORK, DON'T BLOW THE BUTT TRUMPET."

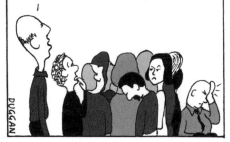

81

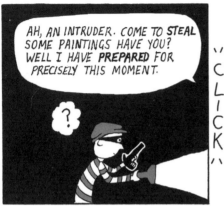

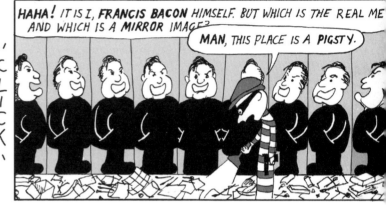

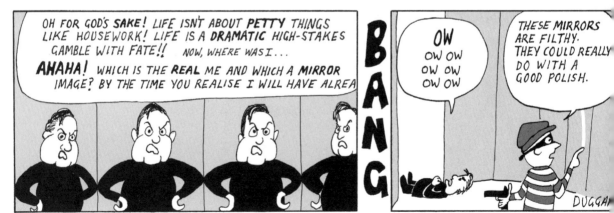

82

THE ART DOCTOR DIAGNOSES THE NUDES OF FAMOUS ARTISTS

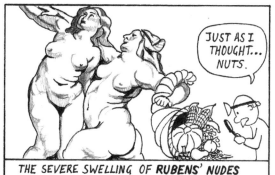

JUST AS I THOUGHT... NUTS.

THE SEVERE SWELLING OF **RUBENS'** NUDES INDICATES AN ALLERGIC REACTION TO CERTAIN **FOODS**

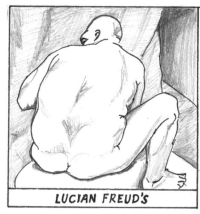

LUCIAN FREUD'S

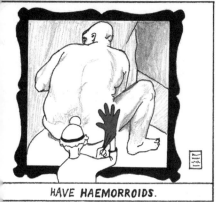

HAVE **HAEMORROIDS.**

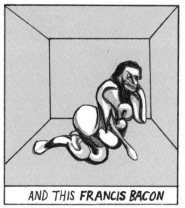

AND THIS **FRANCIS BACON**

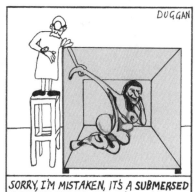

DUGGAN

SORRY, I'M MISTAKEN, IT'S A **SUBMERSED DAMIEN HIRST,** AND IT'S DEAD.

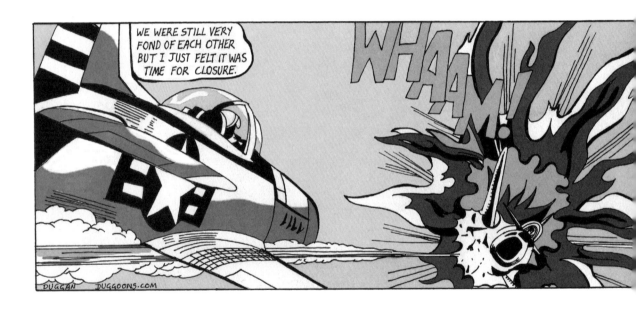

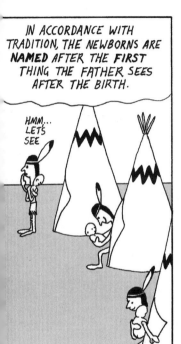
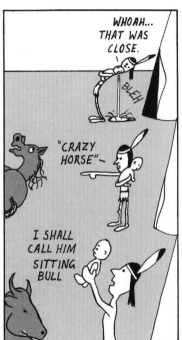
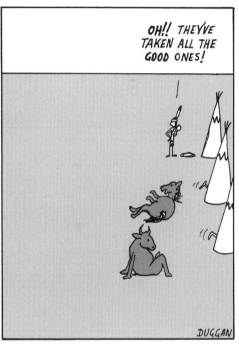

For some reason Chuck Close never really earned the respect of the tribe.
Eventually, he gave up his dream of becoming a fierce warrior leader
and did an arts degree.

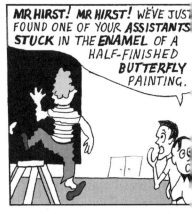
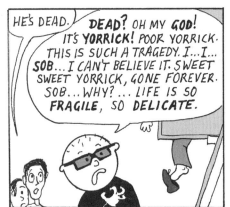
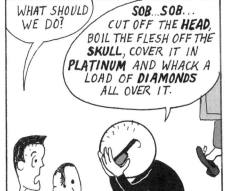
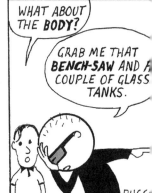

86

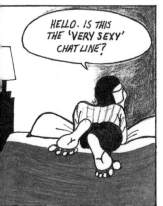

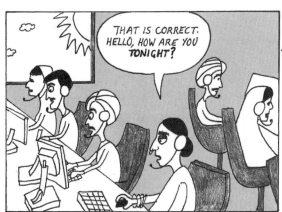

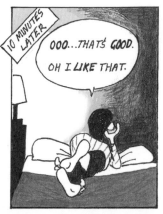

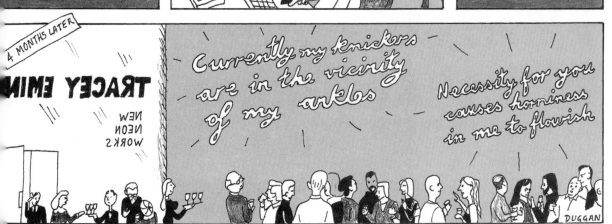

87

VISITORS

This photo album belongs to ..David..Hockney..

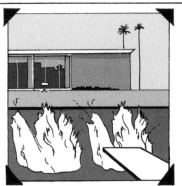

Gilbert and George

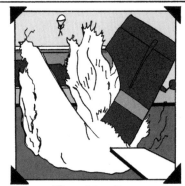

Joseph Beuys

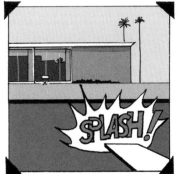

Roy Lichtenstein

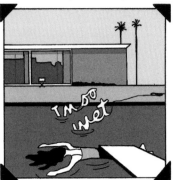

Tracey Emin

VISITORS

This photo album belongs to ...*David Duggan*

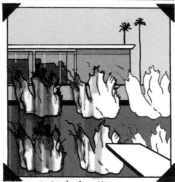

Andy Warhol & the Factory kids

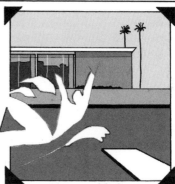

Henri Matisse

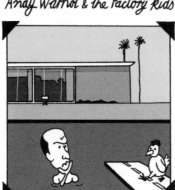

Richard Prince

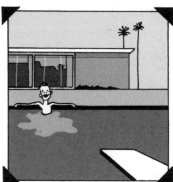

Andres Serrano

DUGGOONS.com

DUGGAN

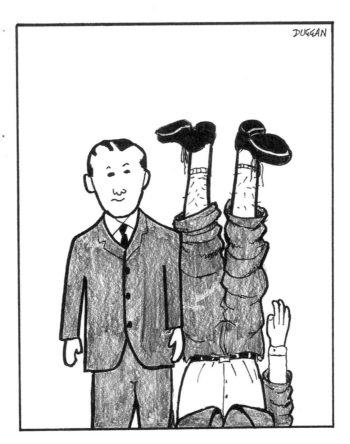

Gilbert and Georg Baselitz

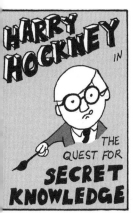

HARRY HOCKNEY IN THE QUEST FOR SECRET KNOWLEDGE

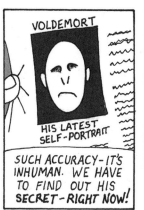

VOLDEMORT

HIS LATEST SELF-PORTRAIT

SUCH ACCURACY—IT'S INHUMAN. WE HAVE TO FIND OUT HIS SECRET—RIGHT NOW!

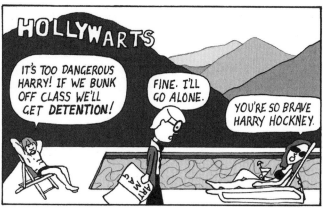

HOLLYWARTS

IT'S TOO DANGEROUS HARRY! IF WE BUNK OFF CLASS WE'LL GET DETENTION!

FINE. I'LL GO ALONE.

YOU'RE SO BRAVE HARRY HOCKNEY.

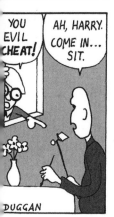

YOU EVIL CHEAT!

AH, HARRY. COME IN... SIT.

DUGGAN

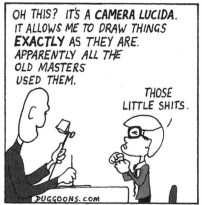

OH THIS? IT'S A CAMERA LUCIDA. IT ALLOWS ME TO DRAW THINGS EXACTLY AS THEY ARE. APPARENTLY ALL THE OLD MASTERS USED THEM.

THOSE LITTLE SHITS.

DUGGOONS.COM

YOU KNOW, "HARRY," YOU ARE NOT WHO YOU THINK YOU ARE.

YOU'RE NOT A NATURAL BLOND.

NO, "HARRY." YOU'RE...

EH?

AYE I AM.

SCRIBBLE

FROM YORKSHIRE!

NORRR

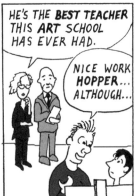

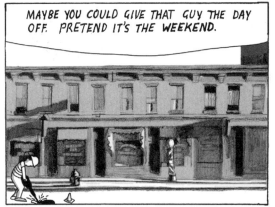

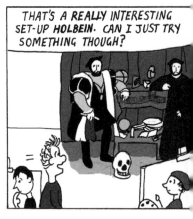

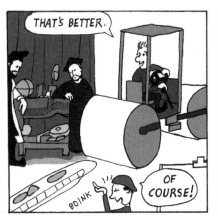

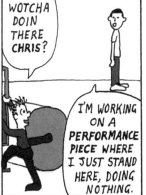

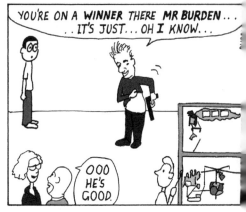

92

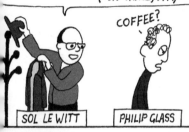

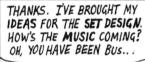

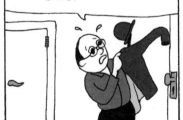

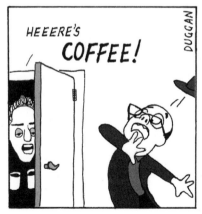

VISITORS

This photo album belongs to ..

Diego Rivera

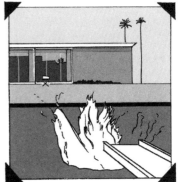

Frida Kahlo

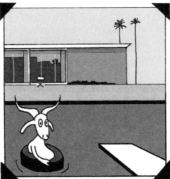

Robert Rauschenberg

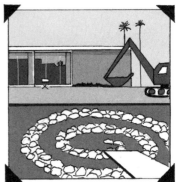

Robert Smithson — what a JERK!

VISITORS

This photo album belongs to ...David Hockney

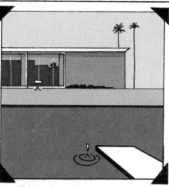

Alberto Giacometti

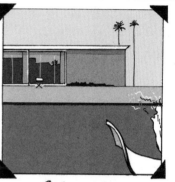

Richard Serra

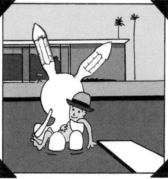

Joseph Beuys

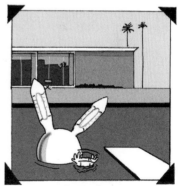

Jeff Koons

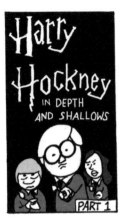

Harry Hockney IN DEPTH AND SHALLOWS

PART 1

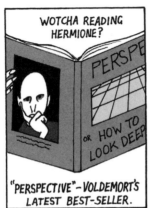

WOTCHA READING HERMIONE?

PERSPE

OR HOW TO LOOK DEEP

"PERSPECTIVE"—VOLDEMORT'S LATEST BEST-SELLER.

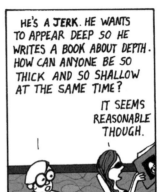

HE'S A JERK. HE WANTS TO APPEAR DEEP SO HE WRITES A BOOK ABOUT DEPTH. HOW CAN ANYONE BE SO THICK AND SO SHALLOW AT THE SAME TIME?

IT SEEMS REASONABLE THOUGH.

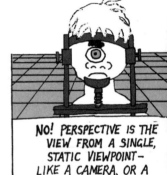

NO! PERSPECTIVE IS THE VIEW FROM A SINGLE, STATIC VIEWPOINT— LIKE A CAMERA, OR A PARALYSED CYCLOPS.

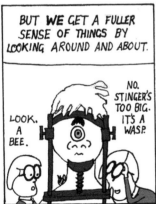

BUT **WE** GET A FULLER SENSE OF THINGS BY LOOKING AROUND AND ABOUT.

LOOK. A BEE.

NO. STINGER'S TOO BIG. IT'S A WASP.

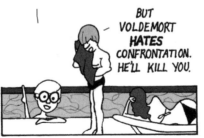

IT'S KIND OF LIKE LOTS OF PHOTOS. **THAT'S IT!** I'LL MAKE AN ARTWORK THAT PROVES MY POINT AND CONFRONT VOLDEMORT WITH IT.

BUT VOLDEMORT **HATES** CONFRONTATION. HE'LL KILL YOU.

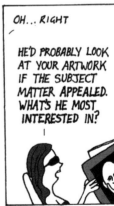

OH... RIGHT

HE'D PROBABLY LOOK AT YOUR ARTWORK IF THE SUBJECT MATTER APPEALED. WHAT'S HE MOST INTERESTED IN?

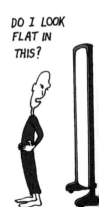

DO I LOOK FLAT IN THIS?

PART 2

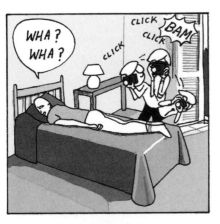

WHA? WHA?

ZZZ

CLICK CLICK CLICK CLICK BAM

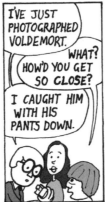

I'VE JUST PHOTOGRAPHED VOLDEMORT.

WHAT? HOW'D YOU GET SO CLOSE?

I CAUGHT HIM WITH HIS PANTS DOWN.

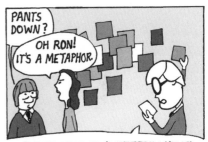

PANTS DOWN?

OH RON! IT'S A METAPHOR.

PERSPECTIVE IS A **FEEBLE** WAY TO DEPICT SPACE. BY JOINING THESE DIFFERENT VIEWS TOGETHER I SHOULD CREATE A MORE COMPLETE EXPERIENCE OF THE SUBJECT.

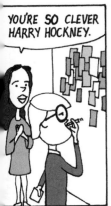

YOU'RE SO CLEVER HARRY HOCKNEY.

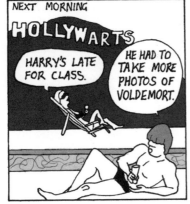

NEXT MORNING

HOLLYWARTS

HARRY'S LATE FOR CLASS.

HE HAD TO TAKE MORE PHOTOS OF VOLDEMORT.

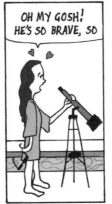

OH MY GOSH! HE'S SO BRAVE, SO

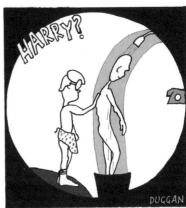

HARRY?

DUGGAN

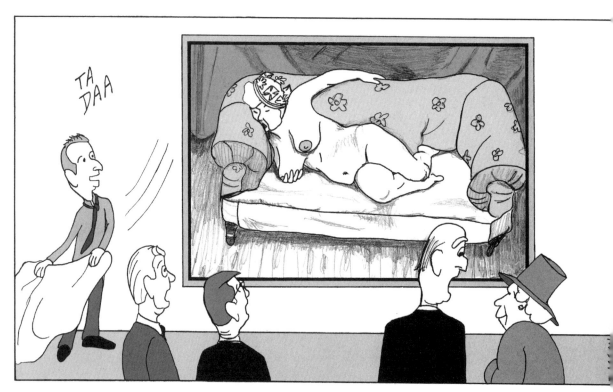

Lucian Freud's first version of the Queen was rejected by the Palace.

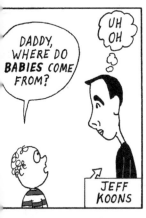

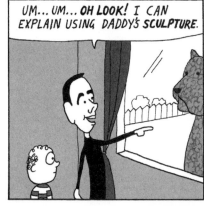

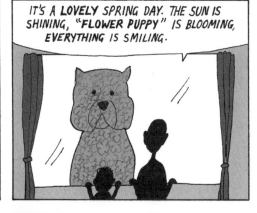

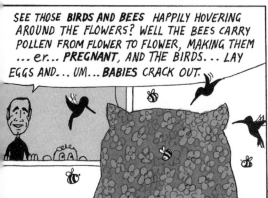

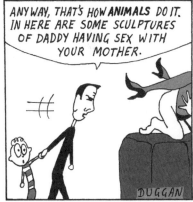

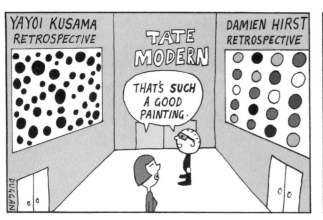

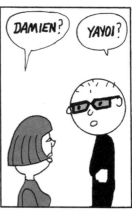

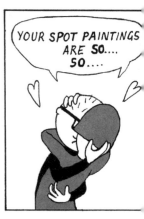

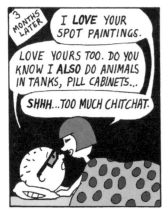

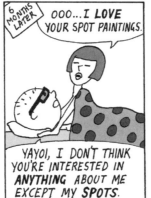

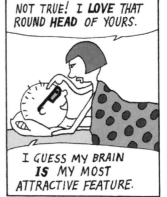

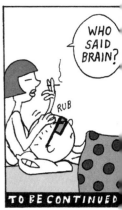

100

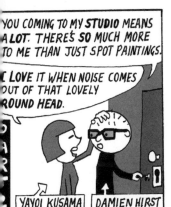

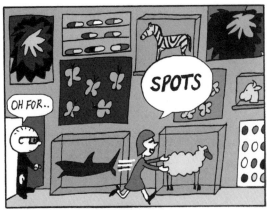

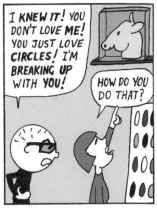

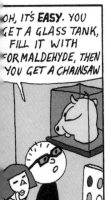

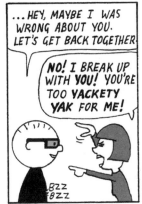

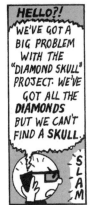

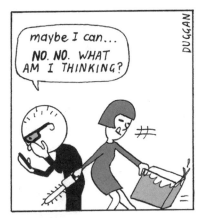

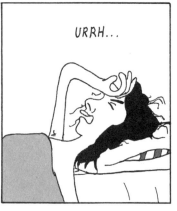

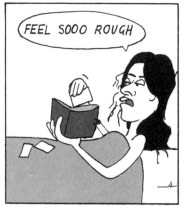

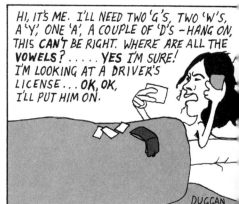

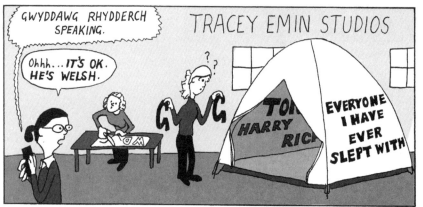

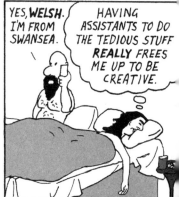

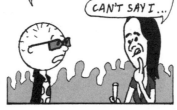

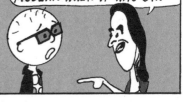

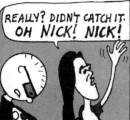

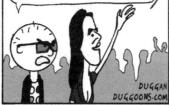

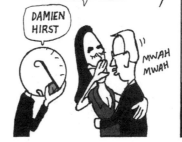

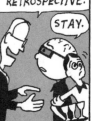

NIGELLA.. I'M BACK. I WON'T **EVER** LOSE MY TEMPER EVER AGAIN. IS **DINNER READY?**

WHAT'S THIS?

IT'S AN **ITALIAN-STYLE** DISH I CREATED. I CALL IT **SPAGHETTI BOLOGNAISE.**

THIS IS THE **BEST** THING YOU'VE EVER COOKED.

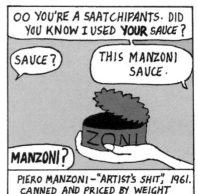

OO YOU'RE A SAATCHIPANTS. DID YOU KNOW I USED **YOUR** SAUCE ?

SAUCE ?

THIS MANZONI SAUCE.

MANZONI ?

PIERO MANZONI – "ARTIST'S SHIT", 1961. CANNED AND PRICED BY WEIGHT AT THE VALUE OF GOLD.

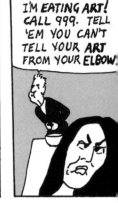

I'M **EATING ART!** CALL 999. TELL 'EM YOU CAN'T TELL YOUR **ART** FROM YOUR **ELBOW.**

I'M BACK. SORRY, BUT YOU'VE GOTTA BE CAREFUL. REAL ART ISN'T **DECORATION** – IT'S **DANGEROUS.** IT

OPENS THE MIND.

BAM!

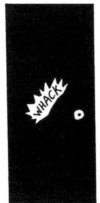

WHACK

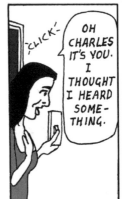

'CLICK'

OH CHARLES IT'S YOU. I THOUGHT I HEARD SOME-THING.

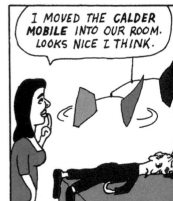

I MOVED THE CALDER **MOBILE** INTO OUR ROOM. LOOKS NICE I THINK.

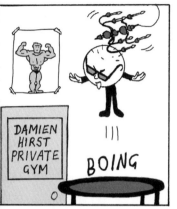

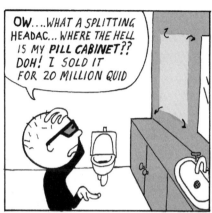

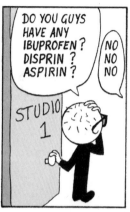

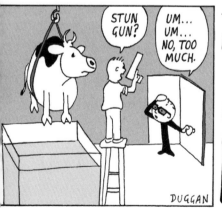

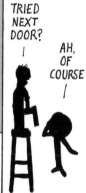

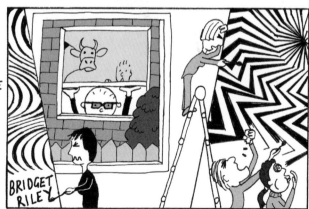

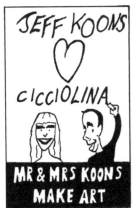

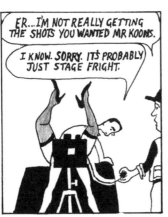

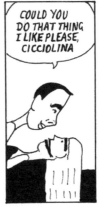

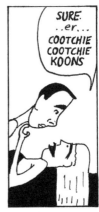

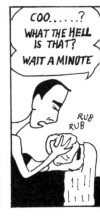

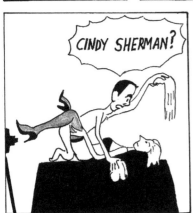

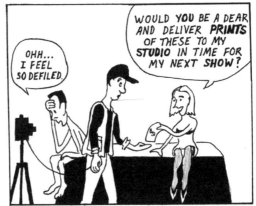

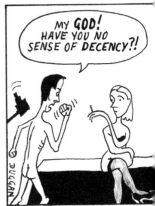

HIGH SCHOOL YEARBOOK *ART CLASS*

Edvard Munch
Alberto Giacometti
Cindy Sherman
Vincent Van Gogh

Dante Gabriel Rossetti
Albrecht Durer
Piet Mondrian
Caspar David Friedrich

DUGGAN

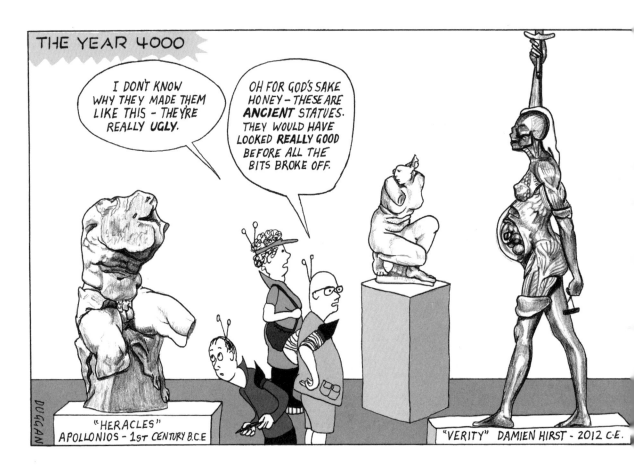

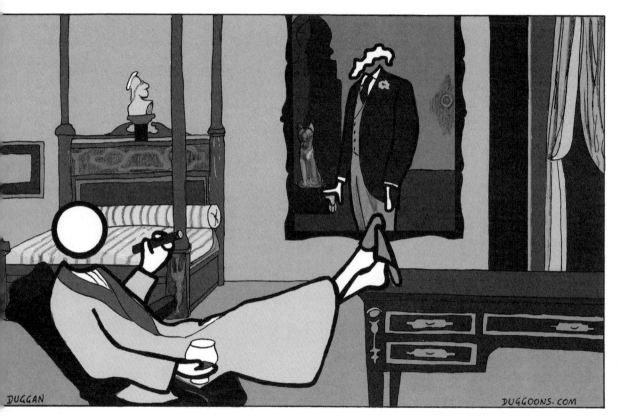

The Picture of Dorian Opie

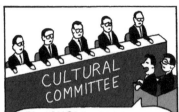

CULTURAL COMMITTEE

TO **COMBAT** THE INSIDIOUS POPULARITY OF **DISSIDENT** ARTISTS, WE PROPOSE AN ARTWORK THAT WILL CAPTURE THE IMAGINATION OF THE PEOPLE – A GIGANTIC, WALKING, TALKING **SCULPTURE**

A **PHOENIX-LIKE** CREATURE CAPABLE OF EATING A **MILLION** SUNFLOWER SEEDS PER HOUR

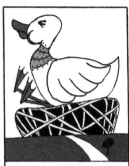

AND LAYING **STADIUM** SIZED EGGS – MADE OF **GOLD!**

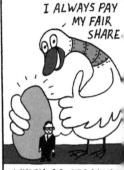

I ALWAYS PAY MY FAIR SHARE

WHICH GO STRAIGHT TO THE **TAXMAN.**

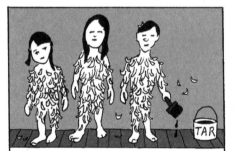

TAR

WE PREDICT CITIZENS WILL PATRIOTICALLY SHOW THEIR SUPPORT BY POSTING **PHOTOS** OF THEMSELVES **ONLINE** DRESSED AS "**THE PEKING DUCK**".

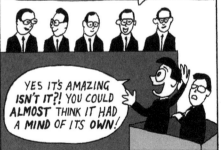

IT BOTH WALKS **AND** TALKS! THE TERM "STATUE" BARELY SEEMS ADEQUATE FOR THIS **IMPRESSIVE** NEW CONCEPT.

YES IT'S AMAZING **ISN'T IT?!** YOU COULD **ALMOST** THINK IT HAD A **MIND** OF ITS **OWN!**

DUNCAN

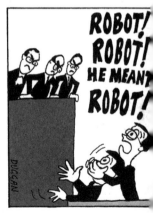

ROBOT! ROBOT! HE MEANT ROBOT!

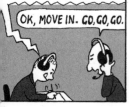
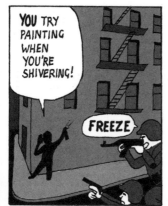
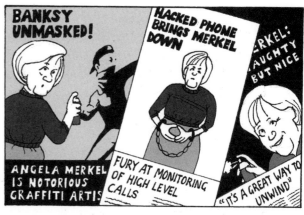

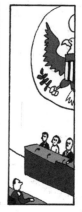
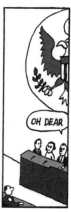

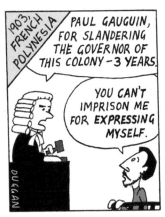

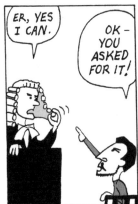

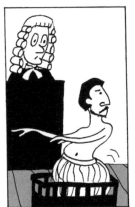

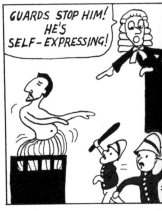

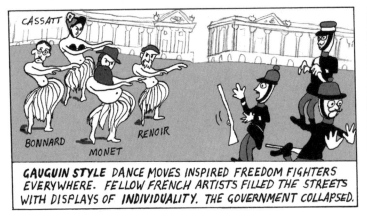

GAUGUIN STYLE DANCE MOVES INSPIRED FREEDOM FIGHTERS EVERYWHERE. FELLOW FRENCH ARTISTS FILLED THE STREETS WITH DISPLAYS OF INDIVIDUALITY. THE GOVERNMENT COLLAPSED.

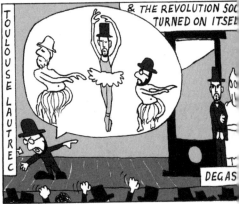

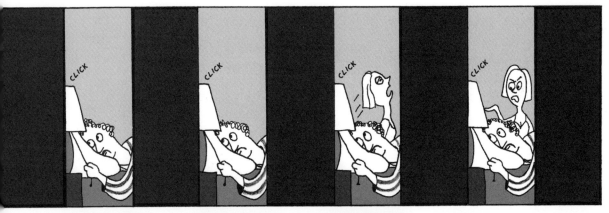

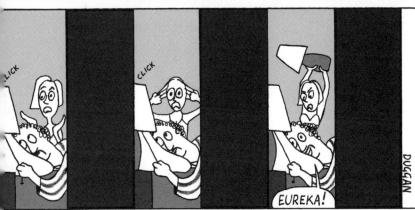

EUREKA!

MARTIN CREED WINS TURNER PRIZE FOR "LIGHTS GOING ON AND OFF."

"HE'S WORKED SO HARD FOR THIS." SAYS PARTNER.

DUGGAN

DUGGOONS.COM

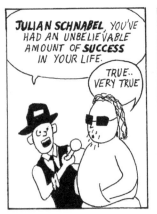

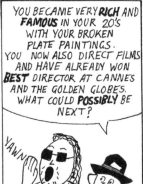

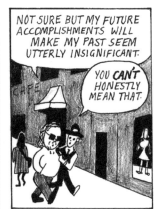

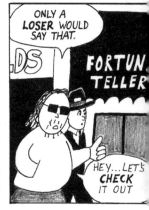

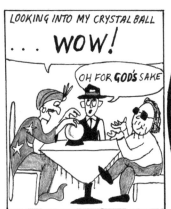

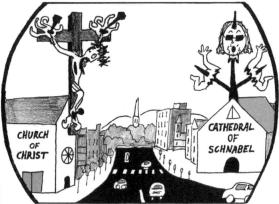

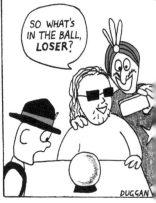

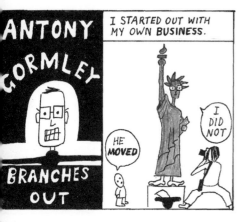

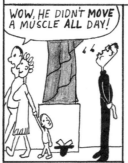

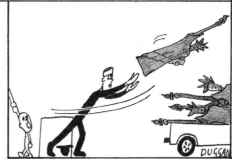

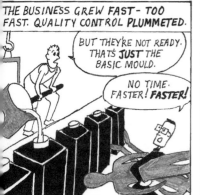

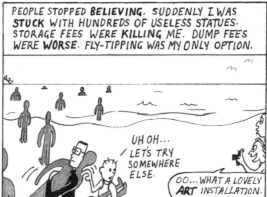

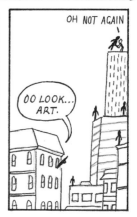

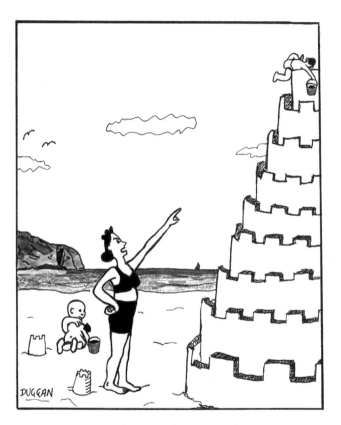

Anselm Keifer, aged 3.

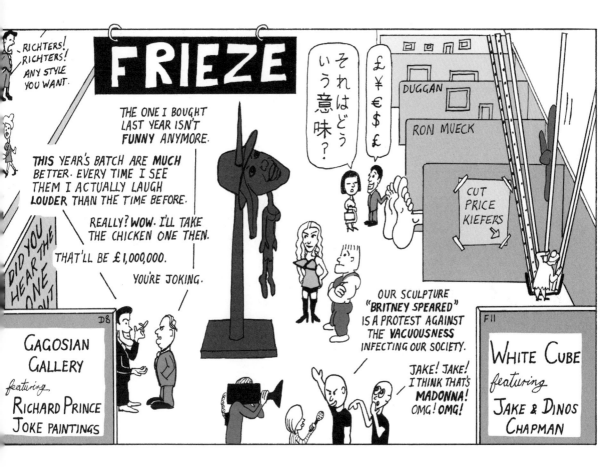

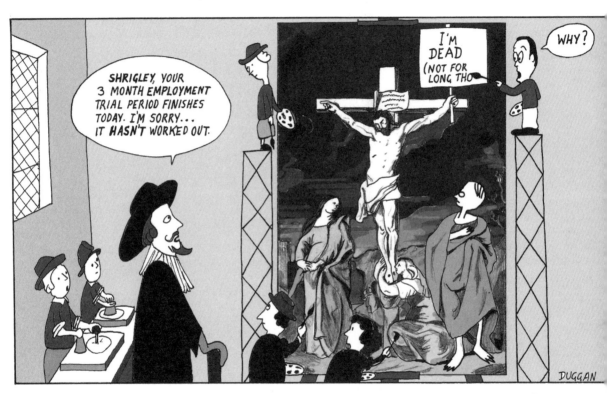

An apprenticeship with an established artist was, for hundreds of years, the only career path available to someone of artistic inclinations.

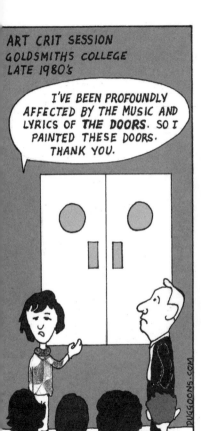

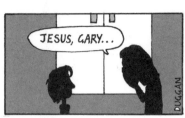

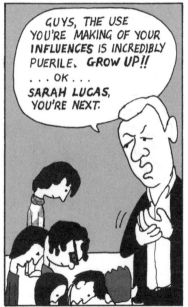

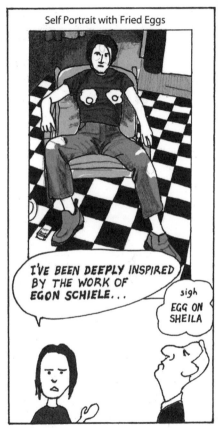

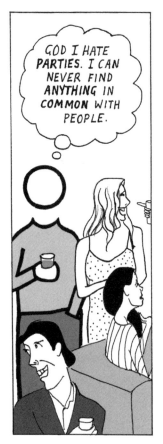

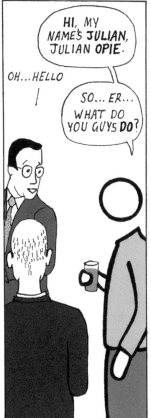

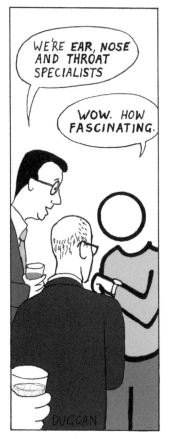

AUTHOR'S NOTE

The blame for this book lays squarely at the feet of my friends Al and Jane. One sunny London afternoon, they suggested I should think seriously about becoming a cartoonist. Never having drawn cartoons before, I found the idea ludicrous. But they persisted, arguing that since I was torn between a love of painting and a habit of making short funny films – between imagery and narrative basically – cartooning could be a happy medium. I could draw my films, and in much less time. It sounded reasonable so I had a crack at it. Some of those first cartoons were deeply strange (a flat head lying on a pavement after knocking over a fence??) but I was encouraged enough to continue, particularly by one about Jackson Pollock. Crafting and refining a joke is a great mental pleasure, that much I knew already, but it slowly dawned on me that the art world could be a cartoonist goldmine – a world where the improbabilities of art could interact with the banalities of life, full of stereotypes, monotypes, 'isms, schisms and loners. Importantly, it was also a world in which my head was thoroughly soaked.

Once I had drawn what I felt were five pretty funny art cartoons, I sent them off to some art magazines – their natural home I thought. I presumed I might get a monthly or perhaps quarterly gig. No bites. In an act of desperation I sent them out to a few of the quality, broadsheet newspapers. Within two days the online division of the *Guardian* got in touch. 'These are great! Can we see some more?' Er, no. 'Would you like to do a weekly strip?' 'Sure' I said, rapidly filling my nappy.

In the steep and very public learning curve that followed, the *Guardian* gave me the odd bit of advice ('Can we have something uber-famous this week – nothing too niche?') but basically left me to my own devices, allowing me to make up the rules as I went along. A fantastic, dream job, for which I am eternally grateful.

A compilation of these cartoons is now in your hands. You could split this book into two parts. However if you did this in the bookshop and you hadn't paid for it then you would have to pay for it. You'll probably want to buy a pristine copy as well. But you will probably notice that while most of the cartoons are about artists or art-making, others simply use the subject matter of a famous artwork as the jumping-off point for a joke. The resulting cartoon often has nothing to do with art at all. This has sometimes confused people who have expectations of what I should be doing. Given my long history of thwarting, I am shocked anyone still harbours expectations of anything I do.

A sizeable chunk of Western art is about religion, so it shouldn't be too much of a surprise to find its haloed head

rearing up in my cartoons every so often. The intention is always to amuse, rarely to offend, but if you feel I have overstepped the mark I would say that where that mark lies is very subjective. The only way to get some degree of objectivity is to buy five or more copies, give them to your friends and see what the consensus is.

Obviously not all the references will be familiar to every reader but hopefully that will only inspire curiosity. Occasionally I see something floating about on the internet where a teacher has used an artoon as an educational tool. This gives me even greater pleasure than a lol (though I fear for the future of the students).

I'd like to thank the Arts editors at the *Guardian* online; Andrew Dickson for his momentary lapse of reason in giving me the gig in the first place, and most especially Kate Abbott, who only occasionally had to tell me I had overstepped the mark. I'd also like to thank Rae Shirvington for introducing me to Virgin Books. I have been pleasantly surprised at what a collaborative process it has been. Elen Jones has steered this book in a happy, unflustered manner, which has made the whole process a joy.

Lastly, this is the opportunity to publicly thank my lovely wife Grace for being a great and honest first reader. 'No darling, it's actually hilarious' was a common refrain of mine as I tried to make her see sense, only to realise that she was the one seeing it. So this book is for her, as well as our little daughter Zoe, who is, in the immortal words of a great landscape painter, simply the best.

INDEX OF ARTOONS AND ARTWORKS

5 **Roy Lichtenstein**: Drowning Girl (1963)

7 **Alexandros of Antioch**: Venus de Milo (between 130 and 100 BCE)

8 **Jan Van Eyck**: The Arnolfini Portrait (1434)

9 **Leonardo Da Vinci**: Leda and the Swan (1508); **Gustav Klimt**: Danae (1907); **Correggio**: Jupiter and Io (1532-1533); **Titian**: The Rape of Europa (1560-62), **Antony Gormley**: Angel of the North (1998); **Fra Angelico**: The Annunciation (1438-1435)

10 **Donatello**

11 **Jan Van Eyck**: Madonna of Chancellor Rolin (1435)

12 **Andrea Mantegna**: Camera degli Sposi (1465-1474)

13 **Sandro Botticelli**: The Birth of Venus (1483-1485)

14 **Leonardo Da Vinci**: Mona Lisa (1503-1517), **Michelangelo Buonarroti**

15 **Michelangelo Buonarroti**: The Creation of Adam (1511-1512)

16 **Leonardo da Vinci**: The Last Supper (1495-1498)

17 **Michelangelo Buonarroti**: David (1501-1504)

18 **Leonardo Da Vinci**: Madonna Litta (1490-1491)

19 **Michelangelo Buonarroti**: The Creation of Adam (1511-1512)

20 **Leonardo da Vinci**: The Last Supper (1495-1498)

21 **Michelangelo Buonarroti**: The Creation of Adam (1511-1512)

22 **Arcimboldo**: Vertumnus (c.1590-1591); Mr Potatohead; **Elias Garcia Martinez**: Ecce Homo (c. 1930); **Cecilia Giminez**: Ecce Homo (2012)

23 **Paulo Veronese**: The Feast in the House of Levi (1573); **Albrecht Altdorfer**: The Martyrdom of Saint Florian (c.1530)

24 **Caravaggio**: The Entombment of Christ (1603-1604), **Derek Jarman**: Caravaggio (1986)

25 **Gian Lorenzo Bernini**: Apollo and Daphne (1622-1625)

26 **Abraham Bloemaert**: Adoration of the Magi (1624)

27 **Alain de Botton and John Armstrong**: *Art As Therapy* (book – 2013); **Frans Hals**: The Laughing Cavalier (1624)

28 **Henri Cartier-Bresson**: Behind the Gare St. Lazare (1932); **Edouard Manet**: The Luncheon on the Grass (1862-1863); **Andy Warhol**: 100 Cans (1962); **Sandro Botticelli**: The Birth of Venus (1483-1485); **Diego Velazquez**: Las Meninas (1656)

29 **Johannes Vermeer**: The Milkmaid (c. 1658), Girl with a Pearl Earring (1665); **Tracy Chevalier** (novel): Girl with a Pearl Earring; A Servant's Life, a Master's Obsession, a Matter of Honour (1999); **Peter Webber** (movie): Girl with a Pearl Earring (2003)

30 **Bartolome Esteban Murillo**: Adoration of the Shepherds (c.1668)

31 **Henry Fuseli**: The Nightmare (1781); **Allen Jones**: Table (1969), Chair (1969)

32 **Jacques Louis David**: The Oath of the Horatii (1784)

33 **Jean-Francois Millet**: The Gleaners (1857), **Jean-Honore Fragonard**: The Swing (1767)

34 **Adriaen van Utrecht**: Vanitas: Still Life with Bouquet and Skull (c. 1642); **Andy Warhol**; **Theodore Gericault**: Anatomical Fragments (1818)

35 **Gustave Courbet**: Bonjour Monsieur Courbet (1854); **John Constable**: The Hay Wain (1821)

36 **Theodore Gericault**: The Raft of Medusa (1818-1819)

37 **John Constable**: The Hay Wain (1821); **J. M. W. Turner**

38 **Eugene Delacroix**: Liberty Leading the People (1830)

39 **William Holman Hunt; Edward Burne-Jones; John Everett Millais; Ford Madox Brown; Dante Gabriel Rossetti**

40 **Theodore Gericault**: The Raft of Medusa (1818-1819), **Georges Seurat**: Bathers at Asnières (1884)

41 **Claude Monet; Edouard Manet**: Olympia (1863), The Luncheon on the Grass (1862-1863)

42 **Eadweard Muybridge**: Animal Locomotion, Plate 197 (Dancing Couple) (1887)

43 **Henri de Toulouse-Lautrec; Edgar Degas**: The Absinthe Drinker (1876); **Edouard Manet**: A Bar at the Folies-Bergere (1882)

44 **Alexandros of Antioch**: Venus de Milo (between 130 and 100 BCE); **Gustav Klimt**: Judith and the Head of Holofernes (1901); **Leonardo Da Vinci**: Leda and the Swan (1508); **Pablo Picasso**: Self-Portrait (1938); **Edouard Manet**: A Bar at the Folies-Bergere (1882); Henri de Toulouse-Lautrec

45 **Edouard Manet**: Olympia (1863), A Bar at the Folies-Bergere (1882), The Luncheon on the Grass (1862-1863)

46 **Paul Gauguin; Vincent Van Gogh**

48 **Edvard Munch**: The Scream (1893)

49 **Paul Gauguin**: The Yellow Christ (1889)

50 **Vincent Van Gogh**: Self-Portrait (September, 1889), Self-Portrait (1887-1888), Self-Portrait (September, 1888), Self-Portrait (late August, 1889), Self-Portrait (Autumn, 1886), Self-Portrait (Summer, 1887); **Paul Gauguin**: Vision after the Sermon; Jacob Wrestling with the Angel (1888)

51 **Edvard Munch**: The Scream (1893)

52 **Henri Rousseau**: The Sleeping Gypsy (1897); **Peter Paul Rubens**: The Lion Hunt (1621)

53 **Vincent Van Gogh**: The Potato Eaters (1885), The Night Cafe (1888), The Starry Night (1889); **Andy Warhol**; **Arthur Sarnoff**: The Hustler (c. 1950); **Jasper Johns**; Flag (1954-1955); **Robert Indiana**: Love (1970)

54 **Auguste Rodin**: The Thinker (1902)

55 **Gustav Klimt**: The Kiss (1907-1908)

56 **Pablo Picasso**: Les Demoiselles d'Avignon (1907)

57 **Luigi Russolo**: The Revolt (1911); **Umberto Boccioni**: The City Rises (1910), Unique Forms of Continuity in Space (1913)

58 **Marcel Duchamp**: Fountain (1917)

59 **Marcel Duchamp**: Nude Descending a Staircase, No.2 (1912)

60 **Salvador Dali**: Lobster Telephone (1936)

61 **Joan Miro**: Constellations series (1939-1941)

62 **Salvador Dali**: Soft Self-Portrait with Grilled Bacon (1941); **Rene Magritte**: The Rape (1945)

63 **Salvador Dali**: The Persistence of Memory (1931), Mae West Lips Sofa (1937); **Rene Magritte**: The Treachery of images (1928-1929)

64 **Salvador Dali**: Lobster Telephone (1936)

65 **Salvador Dali**: Christ of Saint John of the Cross (1951), **M. C. Escher**; **Leonardo da Vinci**: Vitruvian Man (1490)

66 **Salvador Dali**: Lobster Telephone (1936), The Dream (1937)

67 **Rene Magritte**: The Treachery of images (1928-1929)

68 **Edward Hopper**: Nighthawks (1942); **Gottfried Helnwein**: The Boulevard of Broken Dreams (1984)

69 **Diego Rivera; Frida Kahlo**

70 **Pablo Picasso**: Bull's Head (1942); **Lance Armstrong**

71 **Jackson Pollock: Clement Greenberg**

72 **Cy Twombly**

73 **Edward Hopper**: Early Sunday Morning (1930): **Mark Rothko**

74 **Jackson Pollock**

75 **Robert Motherwell**: Elegy to the Spanish Republic; **Vera Mukhina**: Worker and Kolkhoz Woman (1937); **Jackson Pollock**;

L. S. Lowry: Street Scene with Mill (1959)

76 Andy Warhol: Campbell's Soup I (1968); Edvard Munch: The Scream (1893)

77 Roy Lichtenstein

78 Yoko Ono; Peter Blake and Jann Haworth: Sgt. Pepper's Lonely Hearts Club Band cover art (1967); William Blake

79 Roy Lichtenstein: Sweet Dreams Baby (1965)

80 Robert Indiana: Love (1970)

81 Alain de Botton and John Armstrong: Art As Therapy (book – 2013); Andy Warhol: Triple Elvis (1963); Roy Lichtenstein: In the Car (1963)

82 Francis Bacon; Orson Welles: The Lady from Shanghai (movie – 1947)

83 Peter Paul Rubens: The arrival of Marie de Medici in Marseilles (1622-1625), Lucian Freud: Naked Man, Back View (1991-1992), Francis Bacon: Crouching Nude (1961); Damien Hirst

84 Roy Lichtenstein: Whaam! (1963)

85 Chuck Close

86 Damien Hirst

87 Tracey Emin

88 David Hockney: A Bigger Splash (1967); Gilbert and George; Joseph Beuys; Roy Lichtenstein; Tracey Emin

89 David Hockney: A Bigger Splash (1967); Andres Serrano: Piss Christ (1987); Henri Matisse: The Swimming Pool (1952); Richard Prince; Andy Warhol

90 Gilbert and George; Georg Baselitz

91 David Hockney: Rediscovering the Lost Techniques of the Old Masters (2001), Portrait of an Artist (Pool with two figures) (1972); J. K. Rowling: The Harry Potter series of novels (1997-2007)

92 Edward Hopper: Early Sunday Morning (1930); Hans Holbein the Younger: The Ambassadors (1533); Chris Burden: Shoot (performance – 1971); Marcel Duchamp: The Bride Stripped Bare by her Bachelors, Even (The Large Glass) (1915-1923)

93 Sol LeWitt, Philip Glass and Lucinda Childs: Dance (1979); Stanley Kubrick: The Shining (movie – 1980); Stephen King: The Shining (novel – 1977)

94 David Hockney: A Bigger Splash (1967); Diego Rivera; Frida Kahlo; Robert Rauschenberg: Monogram (1955-1959); Robert Smithson: Spiral Jetty (1970)

95 David Hockney: A Bigger Splash (1967); Alberto Giacometti; Richard Serra; Joseph Beuys: How to Explain Pictures to a Dead Hare (1965); Jeff Koons: Rabbit (1986)

96 David Hockney: photo-collages (joiners); J. K. Rowling: Harry Potter and the Deathly Hallows (novel – 2007)

97 David Hockney: The Room Tarzana (1967); Domestic Scene (1963): J. K. Rowling: The Harry Potter series of novels (1997-2007)

98 Lucian Freud: Benefits Supervisor Sleeping (1995)

99 Jeff Koons: Puppy (1992), Dirty - Jeff on Top (1991); Cicciolina

100 Damien Hirst; Yayoi Kusama

101 Damien Hirst: For the Love of God (2007); Yayoi Kusama

102 Tracey Emin: Everyone I Have Ever Slept With 1963-1995 (1995)

103 Damien Hirst; Tracey Emin; Sarah Lucas; Gary Hume; Yayoi Kusama

104 Charles Saatchi; Nigella Lawson; Piero Manzoni: Artist's Shit (1961); Alexander Calder: Untitled (1963)

105 Damien Hirst: Pharmacy (1992); Bridget Riley: Current (1964), Blaze Study (1962)

106 Jeff Koons: Dirty - Jeff on Top (1991); Cicciolina; Cindy Sherman

107 Edvard Munch; Dante Gabriel Rossetti; Cindy Sherman; Caspar David Friedrich; Piet Mondrian; Alberto Giacometti; Albrecht Durer; Vincent Van Gogh

108 Damien Hirst: Verity (2012); Apollonios: The Belvedere Torso (1st century BCE)

109 Julian Opie; Oscar Wilde: The Picture of Dorian Gray (novel – 1891)

110 **Ai Weiwei**: Sunflower Seeds (2010), Beijing National Stadium for the 2008 Summer Olympics (the Bird's Nest Stadium)

111 **Banksy**: Flower Thrower (2003)

112 **Psy**: Gangnam Style (song and music video – 2012); **Ai Weiwei**: Gangnam Style parody video (2012); **Anish Kapoor**: Gangnam For Freedom (video – 2012); **Paul Gauguin**; **Mary Cassatt**; **Pierre Bonnard**; **Claude Monet**; **Pierre-Auguste Renoir**; **Henri de Toulouse-Lautrec**; **Edgar Degas**

113 **Martin Creed**: Work No. 227: The lights going on and off (2001)

114 **Julian Schnabel**: The Diving Bell and the Butterfly (movie – 2007)

115 **Antony Gormley**: Another Place (1997), Event Horizon (2007)

116 **Anselm Kiefer**

117 Frieze Art Fair, London; **Gerhard Richter**; **Richard Prince**; **Ron Mueck**; **Anselm Kiefer**; **Jake and Dinos Chapman**

118 **Anthony Van Dyck**: Christ Crucified with the Virgin, Saint John and Mary (1628-1630); **David Shrigley**: I'm Dead (2010)

119 **Gary Hume**: Four Doors (1) (1989-1990); **Michael Craig-Martin**; **Damien Hirst**; **Sarah Lucas**: Self-Portrait with Fried Eggs (1996)

120 **Julian Opie**

INDEX OF ARTISTS

Altdorfer, Albrecht 23
Angelico, Fra 9
Apollonios 108
Arcimboldo 22
Armstrong, John 81
Armstrong, Lance 70
Bacon, Francis 82, 83
Banksy 111
Baselitz, Georg 90
Bernini, Gian Lorenzo 25
Beuys, Joseph 95, 88
Blake, Peter 78
Blake, William 78
Bloemaert, Abraham 26
Boccioni, Umberto 57
Bonnard, Pierre 112
Botticelli, Sandro 13, 28
Buonarroti, Michelangelo 14, 15, 17, 19, 21
Burden, Chris 92
Burne-Jones, Edward 39
Calder, Alexander 104
Caravaggio 24
Cartier-Bresson, Henri 28
Cassatt, Mary 112
Chapman Brothers (Chapman, Dinos; Chapman, Jake) 117
Chevalier, Tracy 29
Childs, Lucinda 93
Close, Chuck 85
Constable, John 35, 37
Correggio 9
Courbet, Gustave 35

Craig-Martin, Michael 119
Creed, Martin 113
Da Vinci, Leonardo 9, 14, 16, 18, 20, 44, 65
Dali, Salvador 60, 62, 63, 64, 65, 66
David, Jacques Louis 32
de Botton, Alain 81
Degas, Edgar 43, 112
Delacroix, Eugene 38
Donatello 10
Duchamp, Marcel 58, 59, 92
Durer, Albrecht 107
Emin, Tracey 87, 88, 102, 103
Escher, M. C. 65
Fragonard, Jean-Honore 33
Freud, Lucian 83, 98
Friedrich, Caspar David 107
Fuseli, Henry 31
Gauguin, Paul 46-47, 49, 50, 112
Gericault, Theodore 34, 36, 40
Giacometti, Alberto 95, 107
Gilbert and George (Passmore, George; Prousch, Gilbert) 88, 90
Giminez, Cecilia 22
Glass, Philip 93

Gormley, Antony 9, 115
Greenberg, Clement 71
Hals, Frans 27
Haworth, Jann 78
Hirst, Damien 83, 86, 100, 101, 103, 105, 108, 119
Hockney, David 88, 89, 91, 94, 95, 96, 97
Holbein, Hans (the Younger) 92
Holman Hunt, William 39
Hopper, Edward 68, 73, 92
Hume, Gary 103, 119
Indiana, Robert 53, 80
Jarman, Derek 24
Johns, Jasper 53
Jones, Allen 31
Kahlo, Frida 69, 94
Kapoor, Anish 112
Kiefer, Anselm 116, 117
King, Stephen 93
Klimt, Gustav 9, 44, 55
Koons, Jeff 95, 99, 106
Kubrick, Stanley 93
Kusama, Yayoi 100, 101, 103
Lawson, Nigella 104
LeWitt, Sol 93
Lichtenstein, Roy 5, 77, 79, 81, 84, 88
Lowry, L. S. 75
Lucas, Sarah 103, 119
Madox Brown, Ford 39
Magritte, Rene 62, 63, 67

Manet, Edouard 28, 41, 43, 44, 45
Mantegna, Andrea 12
Manzoni, Piero 104
Martinez, Elias Garcia 22
Matisse, Henri 89
Millais, John Everett 39
Millet, Jean-Francois 33
Miro, Joan 61
Mondrian, Piet 107
Monet, Claude 41, 112
Motherwell, Robert 75
Mueck, Ron 117
Mukhina, Vera 75
Munch, Edvard 48, 51, 107
Murillo, Bartolomé Esteban 30
Muybridge, Eadweard 42
Ono, Yoko 78
Opie, Julian 109, 120
Picasso, Pablo 44, 56, 70
Pollock, Jackson 71, 74, 75
Prince, Richard 89, 117
Psy 112
Rauschenberg, Robert 94
Renoir, Pierre-Auguste 112
Richter, Gerhard 117
Riley, Bridget 105
Rivera, Diego 69, 94
Rodin, Auguste 54
Rossetti, Dante Gabriel 39, 107
Rothko, Mark 73
Rousseau, Henri 52

Rowling, J. K. 91, 96, 97
Rubens, Peter Paul 52, 83
Russolo, Luigi 57
Saatchi, Charles 104
Sarnoff, Arthur 53
Schnabel, Julian 114
Serota, Nick 103
Serra, Richard 95
Serrano, Andres 89
Seurat, Georges 40
Sherman, Cindy 106, 107
Shrigley, David 118
Smithson, Robert 94
Titian 9
Toulouse-Lautrec, Henri de 43, 44, 112
Turner, J. M. W. 37
Twombly, Cy 72
van Dyck, Anthony 118
van Eyck, Jan 8, 11
Van Gogh, Vincent 46-47, 50, 53, 107
van Utrecht, Adriaen 34
Velazquez, Diego 28
Vermeer, Johannes 29
Veronese, Paulo 23
Warhol, Andy 28, 34, 53, 76, 81, 89
Webber, Peter 29
Weiwei, Ai 110, 112
Welles, Orson 82
Wilde, Oscar 109

1 3 5 7 9 10 8 6 4 2

Virgin Books, an imprint of Ebury Publishing,
20 Vauxhall Bridge Road, London SW1V 2SA

Virgin Books is part of the Penguin Random House group of companies
whose addresses can be found at global.penguinrandomhouse.com

Copyright © Peter Duggan 2015

First published by Virgin Books in 2015

www.eburypublishing.co.uk

A CIP catalogue record for this book is available from the British Library

ISBN 9780753556962

Printed and bound in China by Toppan Leefung

Penguin Random House is committed to a sustainable future for our
business, our readers and our planet. This book is made from Forest
Stewardship Council® certified paper.